Holography for Photographers

Holography for Photographers

John Iovine

Focal Press
Boston · Oxford · Johannesburg · Melbourne
New Delhi · Singapore

Focal Press is an imprint of Butterworth–Heinemann.

ℛ A member of the Reed Elsevier group

Library of Congress Cataloging-in-Publication Data
Iovine, John.
 Holography for photographers / John Iovine.
 p. cm.
 Includes index.
 ISBN 0-240-80206-3
 1. Photography—Scientific applications. 2. Holography.
I. Title.
 TR692.5.I58 1996
 621.36'75—dc20 96-22864
 CIP

British Library Cataloguing-in-Publication Data
A catalogue record for this book is available from the British Library.

The publisher offers special discounts on bulk orders of this book.
For information, please contact:
Manager of Special Sales
Butterworth–Heinemann
313 Washington Street
Newton, MA 02158–1626
Tel: 617-928-2500
Fax: 617-928-2620

For information on all Focal Press publications available, contact our World Wide Web home page at: http://www.bh.com/fp

10 9 8 7 6 5 4 3 2 1

Printed in the United States of America

Table of Contents

Introduction

As the title suggests, this book is directed toward photographers wanting to learn holography. I must add that you do not have to be a photographer to use this book or to try your hand at (or learn) holography. In fact, most holographers started out with no experience in photography. However, photographers who have a basic understanding of lighting, composition, and tabletop photography will have a head start.

Holography is still considered a new medium even though its roots were first planted in 1947. Holography as we know it today did not really begin until 1963, with the invention and integration of the laser. The technologies and art of making holograms are under development by holo-artists and scientists all over the world. There are many opportunities for finding new and creative methods of producing holograms. Real-time applications for display holography lie in the arts, science, and business.

WHAT IS HOLOGRAPHY?

Holography, like photography, is a process that produces an image on film. The images holography produces are true three-dimensional images called holograms. Holograms incorporate (record and display) the full three-dimensional information about a scene or object, including its depth. The resulting three-dimensional image is "true," meaning it is not a stereographic recording, optical illusion, or trick.

Holography can be a simple process, as this book will illustrate. You do not need to be or become an expert in laser technology, optics, or physics to shoot and develop high-quality holograms. This book will teach you the foundations of holography in a very simple and direct manner. You will learn to shoot different types of holograms using the minimal amount of supplies, equipment, and tools. For instance, a basic holography studio consists of a HeNe laser, an isolation table, optics, film, and development chemistry. These materials and equipment can be assembled and purchased for under $300.

WHY SHOOT HOLOGRAMS?

Holography opens up new vistas for the photographer to explore. The commercial and fine art markets for holograms are expanding. High-quality holograms that are either exceptional or intriguing can be mass-produced cheaply. Mass production does require a substantial initial investment of monies to manufacture the dies used, so you should carefully consider the retail market potential of a hologram before investing in the dies for mass production.

Inexpensive, mass-produced, embossed holograms are commonplace. These are the silver holograms that grace the covers of magazines and comic books. If you own a credit card, it is probably embossed with a hologram to prevent forgery.

A few viable commercial applications for embossed holograms are business cards, stationery, greeting cards, magazines, books, sale displays, and general-purpose labels.

PAST

The theory of holography was formulated by Professor Dennis Gabor of England in 1947. Professor Gabor was looking for a method of improving the resolution of electron microscopes. Holography lay dormant for about 15 years until 1963, when American scientists Emmett Leith and Juris Upatnieks introduced a new invention called the laser to holography. They developed the off-axis split-beam laser holograms that are still used today in many applications.

Working independently, Russian scientist Yuri Denisyak pioneered and developed white light reflection holograms. White light reflection holograms are the most popular type of hologram, because they do not require any special light source to view the image (hence the name *white light reflection*).

Professor Gabor was awarded the Nobel prize in physics in 1971 for his discovery of holography.

PRESENT

Holography markets are expanding. Holograms run the gamut from simple cereal box holograms to fine art holograms of the latest movie and TV characters.

AND FUTURE

Many people envision 3D holographic television to be the primary course holography development will take. Others see the virtual reality market using holographic images before 3D television becomes a reality. While these are worthwhile endeavors, they appear to be distant-future applications, unless a quantum leap is made in technology.

NEAR FUTURE

Development of full-color and true-color holography will continue. This involves working with photosensitive emulsions as well as laser technology.

The performance of solid-state diode lasers will continue to improve, perhaps to the point of making them suitable for holography.

Computers and holography technology will continue to merge, making it possible to easily create computer-generated holograms of objects that don't exist.

Using similar technology, it will be possible to scan people and/or objects in ordinary light and use that scanned information to produce inexpensive holograms (stereograms) of people. This technology already exists, although it is prohibitively expensive for the average person. Eventually the advances in technology will reduce the cost to a more reasonable level.

The image

Most photographic work consists of either displaying or recording the photographic image. This is just as true for holography as it is for photography. This book focuses on *display holography*, that is, holograms created for display purposes—for viewing by people—rather than for some scientific or research purpose.

Although this book will only be concerned with display holography, I must still touch upon its scientific foundation. By understanding this, you will be able to explain to others how holograms work and how they generate their 3D images. It is possible to explain this without getting too technical. Let's ease into holography by comparing it to something you are more familiar with, like photography.

PHOTOGRAPHIC FILM

Like photography, holography records its image on photosensitive emulsions (film). The major distinction between holographic and photographic films is that holographic film has a much higher resolution.

A medium-speed film used in photography has a resolution of approximately 200 lines per millimeter. This means that under laboratory testing conditions, the film is capable of recording 200 distinct lines in the space of 1 millimeter. Naturally, you could only see these individual lines by observing the developed film under a microscope.

There are many films available to a photographer. One important specification is *film speed*. There are fast films and slow films. The fast films are called fast because they require less exposure to light. The slower films require more light, but compensate by delivering higher resolution and a smaller grain structure.

To make a fast film, manufacturers use larger photosensitive silver crystals in the film's emulsion. When developed, the larger crystals naturally form a larger grain structure. Some films are so fast that their grain

structure is large enough to be seen with the naked eye. It follows that these fast films (high ISO) resolve into fewer lines per millimeter than the slower films.

HOLOGRAPHIC FILM

Holographic film requires a much higher resolution than standard photographic film. Holographic films are rated at approximately 8,000 lines per millimeter. The necessity for the higher resolution is that the film must have the ability to record light's interference patterns. Since the wavelength of light is quite small, the interference patterns created by light are proportionally small as well.

When scientists first began creating holograms, only high-quality x-ray film had sufficient resolution to do the job. It's interesting to note that even though x-ray film is black and white, the holographic images produced by the film were often red monochromatic. Today's holographic film is still essentially high-resolution black-and-white film.

Because such a high resolution is needed, very fine photosensitive silver crystals are used in the emulsion. This creates a proportionally slow film. Typically, holographic film has an ISO rating of less than 1.

INTERFERENCE PATTERN

In the last few paragraphs I mentioned the recording of light's *interference pattern* without explaining what an interference pattern is. Since holography is based on light's interference pattern, I think it's best to explain this right now.

The interference of light is based on the wave nature of light. Imagine light waves to be similar to waves created in water. In the case of light, the waves are made out of electromagnetic energy instead of water.

When two light waves of the same frequency meet, they can combine with one another to form a new wave. If the two waves are *in phase*, meaning that the crest of one wave falls onto the crest of the other and one trough falls onto the other trough, the two waves combine constructively, as in Figure 1.1. The waves join together to form a new wave with an amplitude twice as large as the original waveforms. This is called *constructive interference.*

When two light waves of the same frequency meet 180 degrees out of phase, the crest of one wave falls onto the trough of the other, and the waves combine destructively, essentially canceling each other out, as in Figure 1.2.

If a photosensitive emulsion is placed in the light's interference pattern, the areas of constructive interference will expose the photosensitive material, producing a latent image in the emulsion. The areas of destructive interference will be unable to expose the photosensitive material.

In real-world situations, constructive and destructive interference run the whole gamut from partial to complete, in contrast to our two exam-

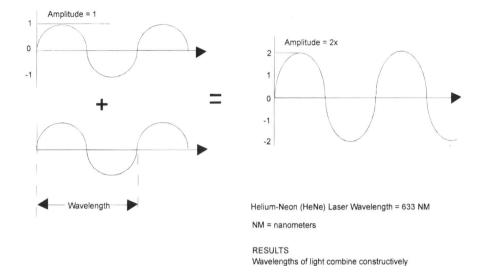

Constructive Interference

Figure 1.1. Constructive interference: two similar waves in phase combining to form a single greater wave.

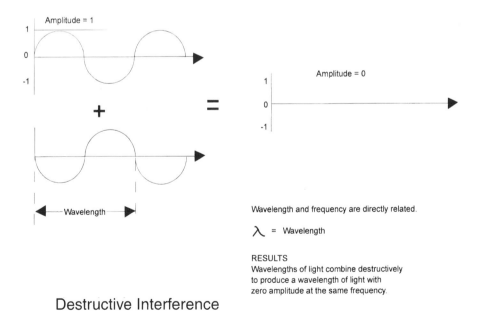

Destructive Interference

Figure 1.2. Destructive interference: two similar waves 180 degrees out of phase combine, canceling each other out.

ples, which have shown the extremes: 100% constructive interference and 100% destructive interference.

LIGHT

Lighting for photography can come from a number of sources: the sun, electric lights, flash tubes, etc. Figure 1.3 is a drawing of a simple lens system used in cameras. The lens forms a real image of the object being photographed. Incidentally, the projected image behind the lens is three-dimensional. However, when the real 3D image produced by the lens falls onto the plane of a piece of film, the third dimension—depth— collapses onto the plane of the film. The resulting photographic image is two-dimensional, with a single, unchangeable viewpoint.

When light activates the silver crystals in the film, you can't see the activated crystals or the image they form yet. The exposed film contains what is called a *latent image* of the object. The latent image can't be seen or used until the film is developed. When the film is developed, the parts of the projected image that were bright (exposed the film to high light intensity) are dark, and vice versa. The density (or darkness) of the film varies in proportion to the intensity of the light that it was exposed to. Therefore, the image is recorded by the varying density in the film.

Notice that there is a reversal. The light areas of the projected image form dark areas on the film and dark portions of the projected image form clear (or semi-transparent) areas on the film; this type of film image is called a *negative*. The negative can be used repeatedly to create a large number of *prints* (positive images) on photographic paper.

In the description of film I have intentionally ignored slide and transparency films, which produce positive images when developed. In addition, I also omitted descriptions of the color response of film dyes and layers. This keeps the descriptions simple and to the point, where they relate to holography. For the most part, these other topics are not relevant to beginning holography. Black-and-white negative film is used as a reference point, because it is commonly understood by the majority of picture-taking people.

Holography does not record an image onto film in the same way a camera does. Holography records the interference pattern of light, generated from a reference beam and reflected light from the subject (an object beam); see Figure 1.4. In Figure 1.4 the light is shown as individual waveforms. Notice that points A and B are points of destructive interference and constructive interference. Only the constructive interference points have the energy to activate, or *expose*, the film's photosensitive emulsion.

Figure 1.5 shows the same illustration as Figure 1.4, but in Figure 1.5 the light is shown as plane waves. Using the plane waves it's easier to see how the interference wave pattern is established and recorded onto the emulsion.

In order for an interference pattern to form, the light source must be *monochromatic* (single light frequency) and *coherent* (wavelengths in

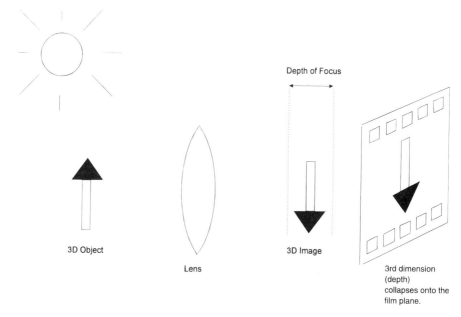

Figure 1.3. Camera lens projecting an image onto film.

phase). A helium-neon (HeNe) laser generates light that meets this description.

Figure 1.6 illustrates a basic split-beam holographic setup. Keep in mind that a split-beam setup is not essential for producing holograms. It is possible to produce holograms using just a single beam. In fact, the first holograms you will start out shooting are single-beam setups. However, the split-beam setup clearly illustrates the recording of the interference pattern created.

The interference pattern forms a latent image on the holographic film. Just like photographic film, the holographic film must be developed in order to show the recorded image.

COPIES

With print photography, the developed film becomes a negative. The negative is used to produce positive prints. A single negative can be used repeatedly to produce thousands of identical pictures.

In holography, there is no negative to produce a print. The original piece of film is the hologram. While it is possible to produce "copy holograms" from a master hologram, the procedure is more complex than using a negative.

If you wanted to mass-produce thousands of holographic copies, it is possible. However, this is in itself a costly and complex process involving master holograms and an embossing technique.

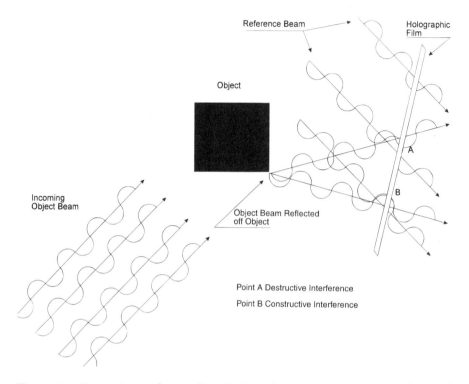

Figure 1.4. Generating and recording the interference pattern, using individual waveforms.

2D PICTURES

The picture, or positive print, made from the negative is two-dimensional. Looking at the photograph from an angle just creates a foreshortening of the flat image and the image remains at the one viewpoint alone.

3D HOLOGRAMS

When the developed hologram is viewed, it generates a true three-dimensional image of the subject. Figure 1.7 demonstrates the parallax of the hologram. In Figure 1.7, a hologram is subdivided into 9 rectangles. A person could look exclusively through any one of the rectangles and see the same holographed object. However, the perspective of the object would match the angle of the observer. In other words, if you move your head to the right, you see more of the object's right side. This is true wherever you move your head. It's as if the object were actually behind the holographic plate. This has led some people to describe holograms as "windows with memory."

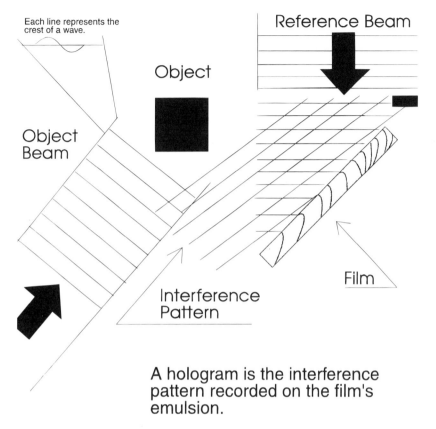

A hologram is the interference pattern recorded on the film's emulsion.

Figure 1.5. Generating and recording the interference pattern using plane waves.

The vertical parallax is from top to bottom, and the horizontal parallax is from left to right. *Parallax* is a term referring to the viewable angles of the subject in the hologram.

The image you see when looking at a hologram is not an optical illusion or trick. If you wanted to, you could take standard pictures (video, still, or movie) of the holographic image from a variety of observer positions. The camera would faithfully record the holographic image as you see it.

3D IMAGE GENERATION

The question remains, how does the hologram generate the 3D image from the recorded interference pattern? The interference pattern produces thousands of lines per millimeter of film. The hologram is really a complex diffraction grating. Consider each interference line to be a tiny mirror. When you view the hologram, light strikes each mirror, reflecting the

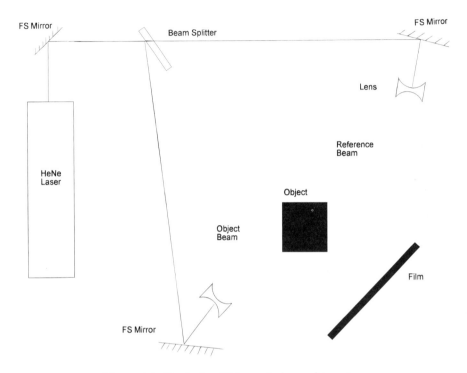

Figure 1.6. Typical split-beam holographic setup.

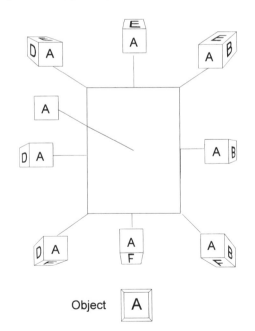

Figure 1.7. Parallax that exists in a hologram.

light toward your eyes exactly the way the original scene (or objects) reflected the light; see Figures 1.8 and 1.9.

This generates—or to use holographic terminology, *reconstructs*— the 3D image. The image appears to be three-dimensional, but it is still more than this. The interference pattern so faithfully records the patterns of reflected light that you can change your perspective (by looking up, down, left, or right) and see the scene exactly as it would appear from each perspective. In essence, you can look around objects.

REDUNDANCY

If an original hologram is broken into pieces, the entire image is still view-able through the broken pieces. This is easier to comprehend if you look at Figure 1.7 again. Imagine that the holographic film is that window with memory I mentioned before. When the window is exposed, any object behind the window, from any viewpoint, is faithfully recorded—so much so that if you covered the hologram using black paper with a peephole in it, you could still view the entire subject through the peephole as if you were looking at it through a window. Where you place the peephole on the window (hologram) determines the perspective from which you see the subject.

The inexpensive silver-embossed holograms you find on magazine covers do not have this holographic *redundancy*. The reason is that dur-

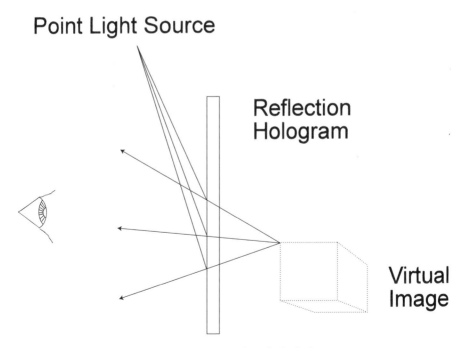

Figure 1.8. Viewing a white light hologram.

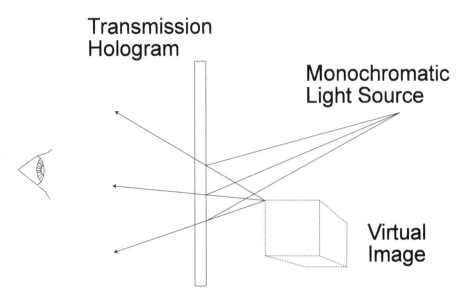

Figure 1.9. Viewing a transmission hologram.

ing the process of making the embossing plates a trade-off is made. Vertical parallax is reduced to increase the general image brightness. Horizontal parallax (left to right) is retained. However, the model is positioned close to the masterplate, again for image brightness, which reduces the observable horizontal parallax.

Most people when looking at a hologram will shift their view from right to left to observe the 3D image. It's unusual to see anyone moving up and down. Therefore, sacrificing the vertical parallax to increase the image brightness is a common practice.

TYPES OF HOLOGRAMS

Regardless of how many names people, artists, and scientists use to describe holograms, there are just two basic types: reflection and transmission. You will find that there are many names that describe subtle variations of these two main hologram types. This book will not investigate all the subtle forms of holograms. Instead, let's understand the two basic hologram types and the differences between them.

WHITE LIGHT REFLECTION HOLOGRAMS

White light reflection holograms are the most familiar and popular type of hologram, the reason being that the hologram is viewable under standard lighting (see Figure 1.8).

This hologram reflects light from its surface, creating the 3D image. This is the type of hologram you will begin shooting.

TRANSMISSION HOLOGRAMS

Transmission holograms require a monochromatic light source for viewing. Often a low-power HeNe laser is pressed into service as a light source. The monochromatic light passes through the hologram. You look into the backlit hologram to view its image. Because of the lighting requirement, transmission holograms are not as popular as reflection holograms; see Figure 1.9.

Transmission holograms are often used as master holograms to produce multiple reflection copies and to create a die for mass-produced embossed-type holograms.

CHAPTER **2**

Equipment

The first step in making holograms is acquiring the needed materials and equipment. The following list covers the essential supplies and equipment you will need to begin shooting a few simple holograms. I will examine each item in the list and offer advice and recommendations on purchasing.

Helium-neon laser

Isolation table

Spreading optic

Holographic film

Safelight

Developing chemistry (developer and bleach)

White alignment card

Black shutter card

Miscellaneous components:

Film holder

Developing trays

Tongs (wood or plastic)

Gloves (wet and dry)

Tungsten halogen lamp

You will need additional components as you advance in the art of holography. These components will be addressed at the appropriate times.

HELIUM-NEON LASER

The first item on the list is the helium-neon (HeNe) laser. The laser provides a suitable light source for holography. The laser you purchase must meet a certain specification in order for it to be capable of producing qual-

ity holograms; primarily it must operate in TEM_{00} Mode. The TEM_{00} Mode specification means that the light produced by the laser is concentrated into a single output beam whose energy is evenly dispersed across the diameter of the output beam; see Figure 2.1. The majority of HeNe lasers manufactured operate in TEM_{00} Mode. Therefore, finding and purchasing a TEM_{00} mode HeNe laser isn't a problem.

The next consideration in choosing a laser is its power output. Power output from HeNe lasers is rated in milliwatts. A milliwatt is equal to 1/1,000 of a watt.

1/2-milliwatt laser = 1/2,000 watt

1-milliwatt laser = 1/1,000 watt

2-milliwatt laser = 2/1,000 watt

5-milliwatt laser = 5/1,000 watt

10-milliwatt laser = 10/1,000 watt

The power output of most HeNe lasers appears minuscule in comparison to a standard household 75-watt incandescent lamp. However, the "unspread" laser beam from a small, 1/2-milliwatt laser is well above the American National Standards Institute (ANSI) standard for eye safety. Looking into an unspread 1/2-milliwatt laser beam would cause physical eye pain. So never, ever look down the barrel of any unspread laser beam!

This situation changes dramatically when the laser beam is spread. For instance, when a 5-milliwatt laser beam is spread to a diameter of 8 inches, it is eye safe and can be looked at directly without any ill effects. Typically, spread beams from lasers are used as monochromatic light sources for viewing transmission-type holograms.

Single-Beam Output

Energy

Diameter

Energy Distribution across
Beam Diameter

TEM 00 Mode

Figure 2.1. Laser beam output TEM_{00} Mode energy distribution.

In holography, the power output from the HeNe laser relates to the exposure time. For instance, shooting a hologram with a 1-milliwatt laser will require a longer exposure time than shooting the same scene with a 5-milliwatt laser. Since you are just starting out in holography and are using small holographic plates, an inexpensive 1- or 2-milliwatt laser is suitable.

NEW OR SURPLUS LASERS

There is a large surplus market of lasers. This is good news because you can purchase a suitable surplus laser for a fraction of the cost of a new laser. Typically, surplus lasers are *pulls*, meaning that the laser was in service in a piece of equipment and was "pulled" out. Whether the laser tube was replaced or the entire piece of equipment was retired is impossible to know.

New laser tubes are rated between 10,000 and 20,000 useful lifetime hours. Although it's impossible to determine the number of hours left on a surplus tube, it's a fair estimate that these laser tubes will have 1,000 to 2,000 hours left. This is equivalent to three to five years of part-time holography shooting.

A 1.25-milliwatt HeNe laser suitable for holography, complete with laser housing and power supply, is available from Images Company for $100.00 (see the "Parts List and Suppliers' Index" section at the end of this chapter). If purchased new, this laser with housing and power supply would cost over $300.00.

LASER SAFETY

As stated previously, *never* look directly into the unspread beam of a laser. An unspread beam from a small, 1/2-milliwatt laser is well above the ANSI standard for eye safety. However, when a low-powered laser beam is spread, it becomes eye safe. For instance, once the laser beam from a 1.5-milliwatt laser is spread to a diameter of 6 inches, it is eye safe. Spread laser beams are commonly used to illuminate and view transmission-type holograms.

Milliwatt HeNe lasers are skin safe. You do not have to worry about the unspread laser beam hitting your skin. These small lasers are well below the minimum ANSI standard for skin safety.

WHERE TO SHOOT

The next thing to consider isn't a supply item or piece of equipment. It is, however, very important: determining where you can set up your holographic equipment to shoot. The area (space, room, etc.) must be quiet (no vibrations) and dark (no light). Although the isolation table will reduce vibrations, it is extremely important to select a space that is as quiet as possible to begin with.

For instance, living in an elevated apartment in a wood-framed building next to railroad tracks with a train passing every 5 minutes would make shooting holograms difficult (not impossible). On the other hand, living in the country, working on a concrete ground floor of a concrete foundation is probably close to ideal. Reality will fall somewhere in between these extremes. Your job is to find the most suitable place possible to shoot. The more suitable the area, the easier it will be to produce good holograms.

DARKROOM

The space you choose must be like a darkroom. You need to be able to turn off all lights and be in complete darkness, except for the illumination of a safelight. If there are windows in the space, you can cover them with black plastic to block out any light. Black plastic can easily and quickly be taped over windows and doors. If you don't have any black plastic handy, you could purchase large plastic trash can liners and use them instead.

To block any light seeping in from under the door, stuff a towel in the space.

When you have the room completely dark, allow your eyes to become accustomed to the darkness and check for any light leaks.

For your first hologram I recommend setting up the holographic isolation table directly on the floor to reduce vibration. A concrete floor in your basement is perfect, but a bathroom or bedroom floor may be OK too.

ISOLATION TABLE

Holograms, as you may have gathered from the "Where to Shoot" section, are very sensitive to vibrations. Vibrations so subtle they can't be felt can prevent the interference patterns (and thus the hologram) from forming. Because of this, holographers always use an *isolation table*. The isolation table, as its name implies, is designed to isolate and dampen as much vibration as possible. The isolation table you will use is cheap, simple, and portable.

Your isolation table consists of three components: a piece of carpet, a small 12–18-inch-diameter inner tube, and a 24-inch-square, 1/8-inch-thick metal plate tabletop; see Figure 2.2. The carpet should be large enough so that the inner tube can lie on it without hanging over the edge. The inner tube has just enough air for it to be filled but still remain very soft. In other words, you could squeeze the sides of it together easily. The top metal plate is the working area. The metal should be thick enough so that it doesn't flex when components are placed on it. The plate I use is 3/16 inch thick. If you cannot get a metal plate to use as a tabletop, you can substitute 3/4-inch or thicker plywood. If you use a plywood table, glue a thin sheet of metal to the top (working) side. The metal allows you to use the magnetic mounting system.

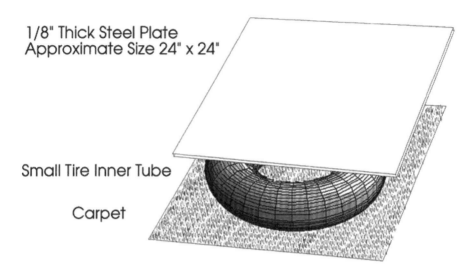

1/8" Thick Steel Plate
Approximate Size 24" x 24"

Small Tire Inner Tube

Carpet

Figure 2.2. Isolation table construction.

OPTICAL COMPONENTS AND MOUNTS

For your first hologram you will keep your optical components to a minimum: 1 small radius mirror. The radius mirror lens is a concave front-surface mirror. The job of the radius mirror is to spread the laser beam. The radius mirror (see Figure 2.3) has a diameter of approximately 3/8 inch. The mirror spreads the laser beam rapidly, allowing it to illuminate an entire 2.5-inch-square holographic plate in laser light within a short working distance of approximately 14 inches. Since your tabletop is approximately 24 inches square, there is more than enough space to set up the table properly.

In some cases optical components are named by their function, in this case a *diverging optic*. A radius mirror is not the only inexpensive diverging optic available. You can also use a negative lens, spherical mirror, or ball lens; see Figure 2.4. I recommend using a radius mirror for the following reasons.

A negative lens doesn't spread (diverge) the laser beam fast enough to be used on a small table like the one you are using. If you had a distance of 4 feet, a negative lens could spread the beam enough to work. In addition to the greater working distance, the laser passing through the lens will pick up any imperfections in the glass. Even though the glass used in the lens appears perfectly clear, it is not. The imperfections picked up by the laser become a part of every hologram shot using the lens.

A spherical mirror spreads the beam fast enough to be used on your table, but although the spherical lens is highly polished, the laser still picks up surface imperfections. For the most part the imperfections are more evenly distributed than in a negative lens and easier to live with. However, the reflectivity of the surface isn't as good as the glass radius

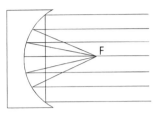

Front-Surface
Reflective Coating

Incident Light

F

Radius Mirror

Figure 2.3. Cross section and function of radius mirror.

mirror and requires a longer exposure. If you use the spherical mirror, double the recommended exposure times.

A ball lens, as its name implies, is a tiny, perfectly spherical ball of glass that functions as a lens. The ball lens spreads the laser beam very fast. The difficulty in using a ball lens is aligning the laser beam to pass through the lens. When the laser passes through glass, imperfections in the glass ball lens are picked up.

SECURING OPTICAL COMPONENTS

You use two different magnets on the isolation table. One magnet measures $7/16 \times 3/8 \times 1$ inch. This is referred to as the *bar magnet*. Optical

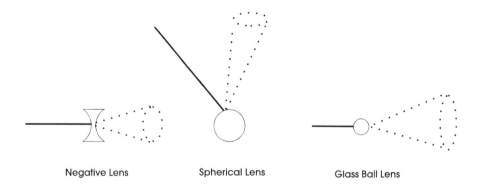

Negative Lens Spherical Lens Glass Ball Lens

Diverging Optics

Figure 2.4. Diverging optics: negative lens, spherical mirror, and ball lens.

components are glued to the bar magnet. The second magnet measures 1 × 1 × 1/2 inch. This is referred to as the *square magnet*. The square magnet is used to attach small steel plates to the surface of the isolation table.

Optical components are mounted to the bar magnets. The optical component/magnet assembly can then be placed on the small steel plates, which measure 1 × 5 × 1/16 inch thick. The steel plates can be assembled in a variety of useful configurations using the square magnets. I advise buying a minimum of four plates and magnets. The basic optical mount configuration is shown in Figure 2.5. The square magnet sticks to the metal top of the isolation table and the 1 × 5-inch steel plate is secured to one side of the magnet.

The radius mirror lens, as described before, is a small concave front-surface mirror attached to a bar magnet using epoxy glue; see Figure 2.6. Be careful not to get any glue or fingerprints on the front surface of the mirror.

When the optical component is glued to the magnet, it is easily attached to the side of the metal plate. This makes the optical component adjustable through a full range of movement; see Figure 2.7. The full range of positioning and movement makes aligning and directing the laser light easy. Figures 2.8A and 2.8B illustrate the radius mirror and optical mount in use.

The optical mount is not restricted to a radius mirror. Other optical components that can be used in a similar manner are a spherical mirror, a ball lens, beam splitters, front-surface mirrors, etc.

FILM

There are a few kinds of film you could use to shoot holograms. My recommendation is to start with 2.5-inch-square holographic glass plates (see the "Parts List and Suppliers' Index" section at the end of this chapter). The part number for the glass plates is 8E75 HD NAH.

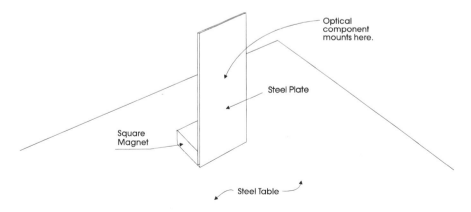

Optical component mounts here.

Steel Plate

Square Magnet

Steel Table

Figure 2.5. Square magnet holding 1 × 5 × 1/16-inch steel plate on tabletop.

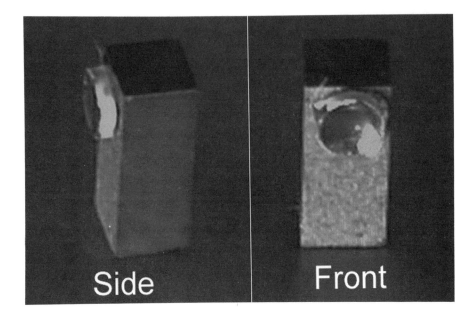

Figure 2.6. Radius mirror glued to magnet. (PCX File)

The 8E75 nomenclature describes red sensitivity. HD stands for High Definition (resolution). The NAH stands for non-antihalation coating.

An AH (antihalation) coating is an opaque coating on the back of the film. It prevents any light from entering the film from the back. This type of film is only suitable for transmission-type holograms.

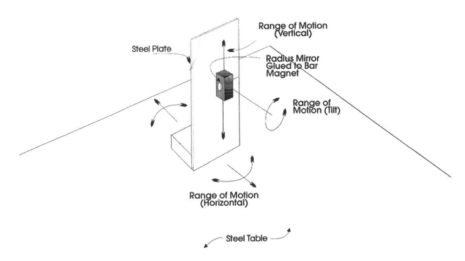

Figure 2.7. Adjustments possible using a magnetic optical mounting system.

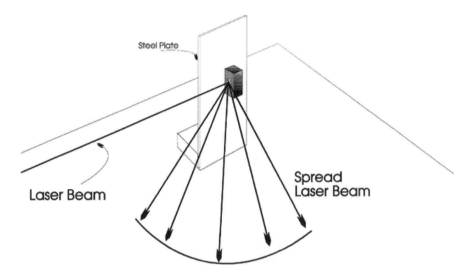

Figure 2.8A. Operation of the radius mirror assembly.

The NAH film has no back coating. Under a safelight, the film plate and emulsion appear transparent. This film allows light to enter from both sides of the emulsion. This film is essential for making white light reflection holograms. It is also suitable for making transmission holograms.

FILM PLATE HOLDER

You need two binder clips with two rectangle magnets to secure the holographic glass plate to the table; see Figure 2.9. The holographic film plate and binder clips must lie flush on the table.

SAFELIGHT

A safelight is essential; it wouldn't be practical to work in complete darkness. You can use any green holographic safelight. The red-sensitive holographic film is least sensitive to green-light wavelengths.

A green safelight provides illumination when setting up a shoot on the isolation table and when developing the holographic film. The only safelight you should buy is one specifically designed for holography (see the "Parts List and Suppliers' Index" section at the end of this chapter).

Keep in mind that no safelight is 100% safe. Film emulsions themselves vary in their sensitivity from batch to batch. To prevent any fogging, always try to keep the safelight 12–24 inches away from the film. This isn't difficult because the safelight is pretty bright. In addition, turn off the safelight when it's not needed.

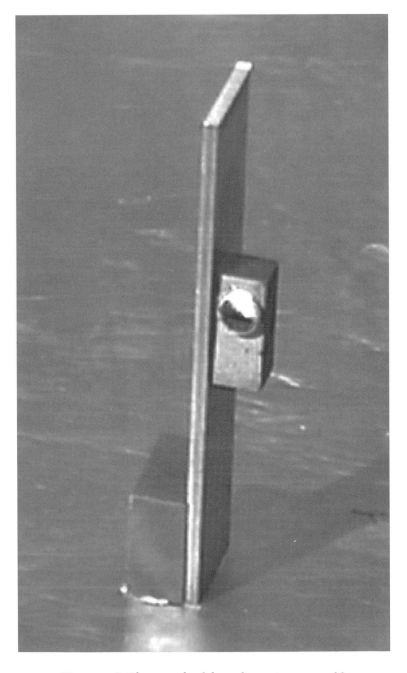

Figure 2.8B. Photograph of the radius mirror assembly.

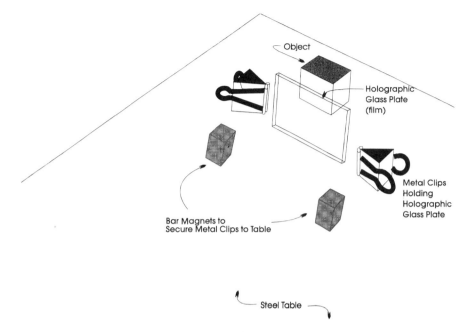

Figure 2.9. Two medium-size binding clips with magnets holding holographic glass film plate to tabletop.

I use a green electroluminescent safelight available from the Images Company. The green light peak on the spectral output of the safelight matches the least-sensitive spectral area on the red-light-sensitive holographic film.

CHOOSING A SUBJECT (OBJECT)

You need to select an object you would like to holograph. I have the following suggestions for object selection. Later, when you have more experience, you can choose other types of objects.

First, the object you select should be smaller than the overall size of the film (2.5 × 2.5 inches). This is so that the entire object will be viewable in the hologram. If you choose to holograph something large, only a small portion will be viewable, making for a less impressive hologram.

Preferably the object will be a light color; white or off-white is good. Objects with a metallic or mirror finish will reflect the laser light in an unpredictable manner, making a diffraction grating where they reflect back into the film plate. If the object you select has such a finish, I recommend buying a clear matte spray and spraying the object to eliminate the reflectivity.

The object should be rigid, something hard and solid that will not flex, bend, or move during the exposure. If the object flexes or bends during the exposure, the hologram will be diminished.

You may think for the moment that the criteria I have provided severely restrict the objects you might choose. Well, to help you along, here's a list of objects you can consider: small seashells (white or painted white), small starfish, acorns, toy cars, HO trains, and models (spaceships, astronauts, monsters, comic book heroes). For my first object I chose a small white seashell.

You can shoot larger and darker items after you gain some experience. To start with, holograph something that will maximize the results obtained using the basic equipment you are working with. The objects outlined will produce bright holograms.

SHUTTER CARD

To make your exposures you use a *shutter card*. The shutter card is moved manually to block and unblock the laser beam. A shutter card is made from a black piece of cardboard or oak tag. On each side is a medium-size binding clip that allows the card to stand upright on the table; see Figure 2.10. The card should be made of black material so that the laser beam isn't reflected or diffused strongly, which can fog the holographic film.

WHITE ALIGNMENT CARD

The *alignment card* helps line up the spread laser beam to maximize its impact on the holographic plate. The card construction is similar to the shutter card. Its size should be that same as the holographic film plate, that is, 2.5 inches square; see Figure 2.11. The card should be made of a white material that allows you to see the spread laser beam easily and clearly.

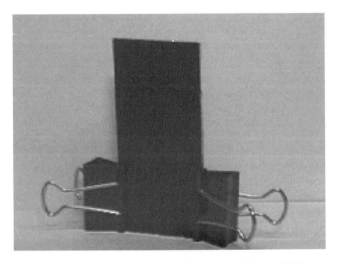

Figure 2.10. Photograph of shutter card. (PCX file)

Figure 2.11. Photograph of white alignment card.

You should also make a large alignment card, about 4 × 5 inches. The larger card will show how far the beam has spread beyond the edges of the 2.5-inch square plate (or small alignment card).

DEVELOPMENT CHEMISTRY

I recommend that you purchase your development chemistry when starting out. Later, if you like, you can mix the development chemistry yourself. For the formulas, check the appendix. The development chemistry recommended in Chapter 3 is sold in liquid form. Each development kit has 8 fluid ounces of developer and bleach.

TRAYS

You will need three trays to develop holograms. The trays should be large enough to put the glass film in, but not so large that the 8 ounces of development chemistry won't easily cover the plate. Again, to keep things simple, I advise purchasing the trays.

GLOVES (WET AND DRY)

The developing chemicals are toxic and can be absorbed through the skin. Even if you plan to use photographic tongs to develop your holograms, I still recommend using gloves. Gloves prevent the developing chemistry from coming in contact with your skin. The gloves you use can be any number of lightweight waterproof gloves, like Playtex®. These will adequately protect your hands when developing holograms.

You may also invest in a pair of white cotton gloves. Wear these gloves when handling the glass holographic plate. The cotton gloves will prevent you from getting fingerprints on the holographic plate when set-

ting it up on the isolation table. Fingerprints may show up later, after the plate has been developed.

TUNGSTEN HALOGEN LAMP

The tungsten halogen lamp is an excellent light source for viewing holograms.

PARTS LIST & SUPPLIERS' INDEX

From Images Company:
Images Company
P.O. Box 140742
Staten Island, NY 10314
(718) 698-8305

Table top, 24 × 24 × 3/16 inch thick, weight 30 lbs (less shipping)	$70.00
Inner tube, approx. 17-inch diameter	$12.95
Steel plate, 1 × 5 × 1/16 inch thick	$2.00
Radius mirror	$36.00
Spherical mirror	$6.00
Bar magnet	$2.50
Square magnet	$5.00
Developing trays	$5.00
24 pcs holographic film, 2 × 2.5 inches	$36.00
30 pcs holographic film, 2.5-inch-square glass plates	$160.00
Film holder, 2 plastic plates, clips, and magnets	$10.00
Green safelight	$35.00
IM-1 holographic developing kit	$18.00
1.25-milliwatt HeNe Laser TEM_{00} Mode (surplus)	$99.00
Tungsten halogen lamp	$25.00

Reflection holograms

Reflection holograms are viewable in standard lighting. Because of this, they are the most popular type of hologram available for commercial purchases.

Reflection holograms were first created in the early 1960s by Yuri Denisyak working in the Soviet Union. His optical process deviated from what Dennis Gabor had accomplished in 1947 and also from the transmission holograms Leith and Upatnieks were developing at the University of Michigan.

Denisyak's approach had the object beam and reference beam striking the emulsion from opposite sides. The two beams created a standing wave pattern (interference pattern) that is recorded by the film emulsion.

Because this process resembled the photographic process developed by Gabriel Lippmann, who in 1891 created color photographs by recording the interference pattern of light, Denisyak named this new type of hologram "Lippmann."

Today, reflection-type holograms may be called Denisyak-type holograms, Lippmann-type holograms, volume holograms, white light reflection holograms, or reflection holograms.

SHOOTING YOUR FIRST HOLOGRAM

The first hologram you will shoot is a single-beam white light reflection. As stated earlier, this type of hologram is viewable in standard light.

It's a good idea to read through all the instructions completely before you start. This will save some wear and tear on your nerves and probably some holographic film too.

To begin, turn on your HeNe laser. The laser must be given ample time to warm up and stabilize before you begin shooting. Usually, 20–30 minutes before you expect to expose a plate is sufficient time.

STEADINESS CHECK

Before shooting any holograms it is important to check the isolation table for vibration. Typically, checking an isolation table for vibration involves the construction of an interferometer; however, there is a much simpler method you can use. See Appendix C, "Steadiness Check," for instructions.

Materials needed:

One steel plate with square magnet (for making optical assembly for radius mirror)

One radius mirror mounted to bar magnet

One holographic plate

One model (mounted or secured to table)

One medium-size binding clip with magnet to secure holographic plate

One shutter card

One white alignment card

*Note: HeNe laser and isolation table are not listed, because they are part of every setup.

SECURING THE OBJECT

The object you selected must be secured to the table in a way that prevents it from moving or rocking during the exposure. One of the easiest ways to accomplish this is by putting a ball of clay on the table where you are placing the object. Then push the object into the clay; see Figure 3.1. Instead of clay, you could also use "Fun-Tak" material. Fun-Tak is a blue material that has the consistency of clay. It can be pulled apart and pushed together again, rolled into balls, etc. The material is reusable and, because of its strong adhesive properties, is worthwhile to purchase.

Another way to secure an object is to glue it to a magnet and position it on the table by using steel plates; see Figure 3.2. Notice in this illustration that the coral is glued to a bar magnet. The steel plate and square magnet are the same as used for the optical mounts. The coral's height and angle can be adjusted to maximize its position for holography.

You can also glue the object to a transparent piece of plastic, then secure the plastic to the table; see Figure 3.3. This type of mounting makes the object appear to float in free space.

FINDING THE OBJECT AND FILM POSITION ON
THE TABLE

The laser beam must evenly illuminate the object through the transparent holographic film plate. Therefore, the object is positioned directly behind the film plate. The closer the object is to the plate, without touching it, the brighter the resulting hologram.

Figure 3.1. Object secured to the table with clay.

Set up the holography table as illustrated in Figure 3.4. The laser can be placed on or off the table. For this exercise, the laser is positioned on the table.

The laser power supply is kept off the table. Some power supplies give off a 60-cycle hum that may vibrate the table and ruin any holograms. If your laser's power supply is encased within the laser housing, you may want to position the laser off the table.

Set up a steel plate (5 × 1 × 1/16 inch thick) and square magnet on top of the isolation table. Position the steel plate and magnet assembly so that the beam passes alongside the plate. Attach the magnet holding the radius mirror to the steel plate. Position the mirror/magnet assembly to reflect the diverging laser beam diagonally across the table as in Figures 3.4 and 3.5.

Position the white card where you think the film plate should be located. Place a rectangular magnet on each binding clip to secure the position. Adjust the radius mirror so that the beam reflected from the mirror is spread evenly on the white card. The spread beam should cover the white card completely. If it doesn't, move the card farther away from the radius mirror. Keep moving the card back until the spread beam covers it completely and secure the position there.

Figure 3.2. Object glued to magnet secured to table.

Any imperfections in the laser beam will easily be seen on the white card. The spread beam should be free from obvious imperfections. If there are any obvious imperfections showing, move the radius mirror slightly so that the laser beam is striking a different portion of the mirror. This takes a little practice, because each time you move the radius mirror it must be realigned. Keep moving and aligning the mirror until the spread beam is as clean as possible.

If it is impossible to obtain a clean beam from the radius mirror, it probably needs to be cleaned. See "Cleaning the Radius Mirror" and the sections that follow in Chapter 6.

The spread laser beam should strike the card from an approximate angle of 45 degrees; see Figure 3.5. This is an important aspect of holography. Because the angle at which the HeNe beam strikes the film is the

Figure 3.3. Object secured to transparent plastic; plastic secured to table.

needed angle, light will have to strike the hologram to reconstruct the holographic image.

Therefore, if you have the laser striking the film plate at 90 degrees, the light source needed to reconstruct the image will end up right behind the observer's head. This is not very convenient and can be quite frustrating. For this reason, holographers typically employ angles between 30 and 45 degrees.

Position the object you are going to shoot right behind the card. Remove the white card, leaving the magnets and binding clip(s) in position. The laser is now illuminating the object you are going to holograph. The object should be positioned as close as possible to the holographic film plate.

Look at the object from the laser side; this is what your finished hologram will look like. Make any adjustments you want to the object in order to holograph it in the best possible position.

Figures 3.6 and 3.7 illustrate the distance between the object and the plate for single-beam reflection holography. If you were shooting the shell placed in the clay, the position of the film plate in relationship to the shell is illustrated in Figure 3.6. Figure 3.7 shows the film position to holograph the acorn mounted to the transparent plastic.

SHUTTER THE LASER

When everything is aligned to your satisfaction, block the laser with the black shutter card; see Figure 3.5 for the shutter card position. I usually

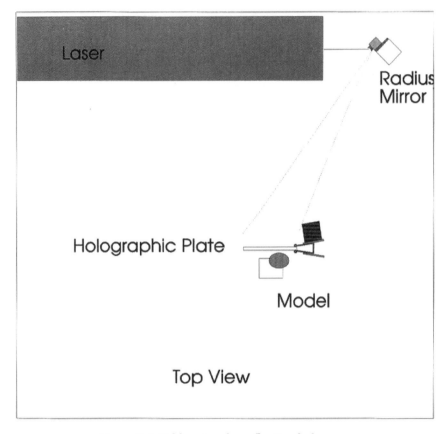

Figure 3.4. Table setup for reflection hologram.

position the shutter card to block the laser beam before it hits the radius mirror and diverges.

PLACING THE FILM IN POSITION

Figure 3.8 is a picture of the light-tight box the holographic plates come in. Remove the protective tape from the box. Under safelight conditions, open the box and remove one glass holographic plate. Hold the holographic plate by its edges. Replace the cover of the light-tight box immediately. Carry the plate over to the isolation table and place the film plate in the binding clips positioned earlier. When you look at the holographic plate under the safelight, the plate appears completely transparent, but there is an emulsion on one side of the glass.

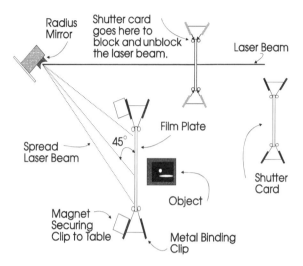

Radius Mirror

Shutter card goes here to block and unblock the laser beam.

Laser Beam

Film Plate

Spread Laser Beam

45°

Object

Shutter Card

Magnet Securing Clip to Table

Metal Binding Clip

Figure 3.5. Illustration of table setup.

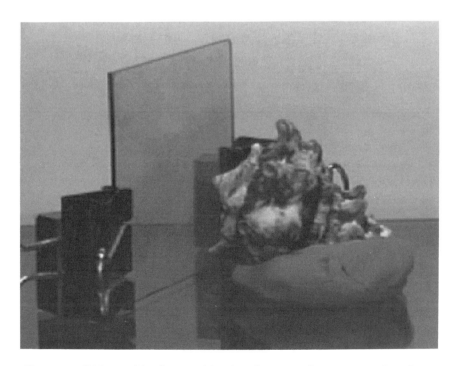

Figure 3.6. Holographic plate position in relation to object mounted in clay.

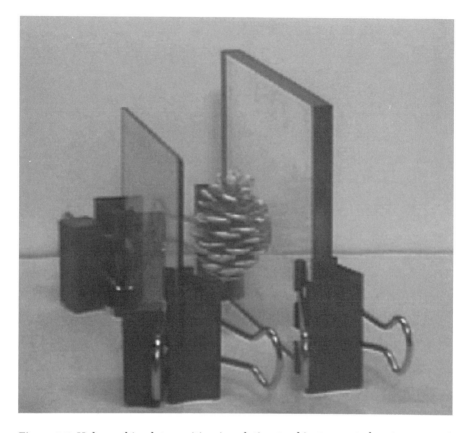

Figure 3.7. Holographic plate position in relation to object mounted on transparent plastic.

EMULSION SIDE

When shooting holograms, you usually want the emulsion side of the plate facing the model or object you are holographing, the reason being that when someone is viewing the virtual image, the emulsion side will be opposite the viewer and protected by the glass. This is even more important when mounting holograms for viewing. Anyone touching the hologram will be touching the glass, rather than the emulsion.

Since the holographic glass plate (and the emulsion) appears transparent, holographers usually use the lip test to find out which side of the glass plate the emulsion is on. Hold the plate in your hand and bring a corner of the plate to the inside corner of your bottom lip. Place the plate on your inside lip just where it is moist. Touch one side of the plate to your lip, then the other. The emulsion side is the slightly sticky side.

When placing the plate in the holographic setup, position it so that the emulsion side is facing the model. Don't worry if you position the plate incorrectly. You will produce a hologram regardless of which way

Figure 3.8. Light-tight film box.

the emulsion is facing when you shoot (one of the advantages of using NAH film). Facing the emulsion side properly just helps protect the emulsion for subsequent viewing.

Take your time placing the glass plate film in the binding clips. It is important that the binding clips, glass, and magnets lie flush on the table. This provides maximum stability to the holographic plate. I get the best results by first laying the glass on the table in the correct position, then attaching one binding clip to one side, securing the magnet, and finally attaching the second clip and magnet.

Figure 3.9 shows a bad film setup. The glass plate is locked in position off the table. Figure 3.10 isn't much better. Here the plate is on the table and the clips are lifted off. Figure 3.11 is a good setup. The plate, clips, and magnet are flush against the table, giving maximum stability to the holographic plate.

In many holographic setups I use just one binding clip and magnet to secure the glass film plate in position. While this works in the great majority of setups, it is more susceptible to vibration.

After the holographic plate has been positioned, remove your hands from the table and setup for 1 minute. This will allow any vibrations to die down.

TIMING THE EXPOSURE

The exact exposure time varies with the intensity of the laser light and the sensitivity of the film. Assuming that you are using a radius mirror

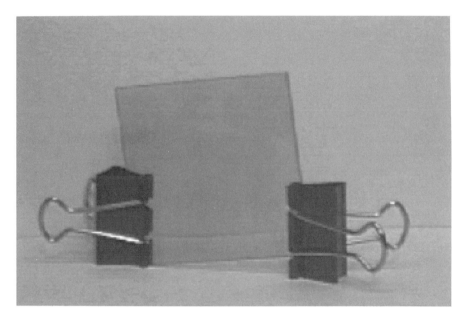

Figure 3.9. Bad holographic plate setup—film plate lifted off table.

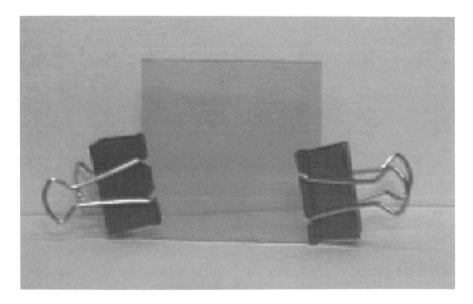

Figure 3.10. Bad holographic plate setup—binding clips not flush to the table.

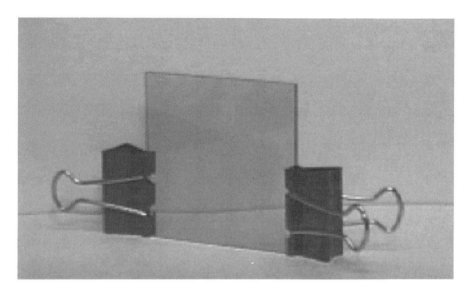

Figure 3.11. Good film setup—plate, clips, and magnets flush against the table.

with the laser beam spread to a diameter of approximately 3 inches, use the following exposure times as a start.

EXPOSURE TIMES

Laser Power	Exposure Time
1-milliwatt laser	6 seconds
1.25-milliwatt laser	5 seconds
2.5-milliwatt laser	3 seconds
5-milliwatt laser	1.5 seconds

If you are using the steel spherical mirror, double the exposure times.

To gauge the best exposure time for your hologram you will need to make a test exposure strip on a holographic plate. The procedure and list of materials needed to make a test strip are at the end of this chapter.

MAKING AN EXPOSURE

To make the exposure, lift the shutter card off the isolation table, but keep it in a position that still blocks the laser beam (see Figure 3.12). When lifting the shutter card off the table, do so as smoothly and gently as you can, to cause the table to vibrate as little as possible. Hold the card in the midair position, still blocking the laser beam, for 30 seconds, to allow any

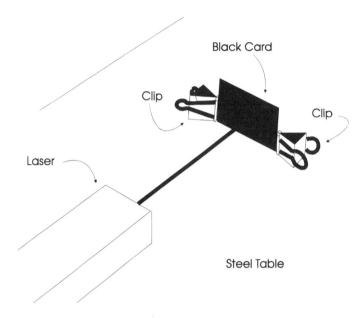

Figure 3.12. Shutter card blocking the laser.

vibration caused by lifting the card off the table to die down. Then lift the card completely, allowing the laser to expose the plate.

After the exposure time has elapsed, put the card back down, blocking the laser beam again. When replacing the card, don't worry about vibration. Once the laser is blocked, the exposure is complete and vibration will no longer affect the outcome. The plate is ready to be developed.

THINGS TO WATCH OUT FOR

When making the exposure, stay in one comfortable position. Don't bounce around or shift your weight from one leg to another during the exposure. This may cause some vibration to creep in, especially if you are working on wood floors.

Some people like to listen to music when working in a darkroom for an extended period of time. That's fine, *except* when making a holographic exposure. The music could cause the plate or isolation table to vibrate, preventing or diminishing the hologram. It's OK to listen to music when setting up the table and film development, but never during the exposure itself.

DEVELOPING YOUR HOLOGRAM

Materials needed:

Developer solution

Bleach solution

Water

Three trays

Tongs

Rubber gloves

Safelight

Watch or timer

Developing your hologram requires just three steps:

1. Developer 2–4 minutes (until the plate reaches a density of 80% dark)
2. Water bath 1 minute
3. Bleach 1 minute (or until clear)

You must take care when handling the development chemistry. Although the chemistry is no more dangerous than most photochemistry, that still means the chemicals are toxic and can be absorbed through the skin. For this reason you should always wear gloves when using the chemicals. For added protection, you could also wear a rubber apron and goggles. Even though you use tongs to move the holographic film from tray to tray, you should still wear rubber (Playtex) gloves.

Three small plastic trays are needed develop the exposed plate. The trays should be large enough to hold the plate. The trays are arranged as in Figure 3.13. The first tray holds the developer, the second tray water, and the third tray contains the bleach.

The developer kit (see the "Parts List & Suppliers' Index" section in Chapter 2) contains 8 fluid ounces of developer and 8 fluid ounces of bleach. The chemicals are reusable. The chemistry has a shelf life of 3–6 months in a closed bottle, and about 8 hours in an open tray. It's a good idea to re-bottle the chemistry as soon as you're finished developing your holograms. If you need to keep the chemistry in the trays for extended periods of time, you can cover the trays with a sheet of plastic or glass to slow down the oxidation.

Developing a Hologram

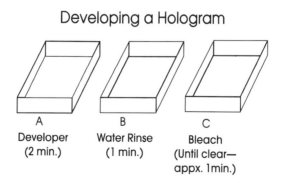

Figure 3.13. Three developing tray setup.

Use a safelight for illumination during development. Place the holographic plate in the developer. The time the plate stays in the developer will vary between 2–4 minutes. Ideally, you want the plate to achieve a density of 80% dark by eye. Every 20–40 seconds, gently rock the tray or move the film back and forth with wooden photography tongs to keep fresh solution in contact with the film. Check the plate's density by removing it from the developer with the tongs and looking at the safelight through the plate. As soon as the plate reaches 80% dark by eye, remove it from the developer tray and move to the next step in developing.

Underexposed

If the plate doesn't achieve this density after 4 minutes, it is underexposed. Keeping the plate in the developer longer than 4 minutes will not increase its density. Do not get discouraged; continue on to the next step with development—you may still have a hologram. Since the hologram is underexposed, make a note to increase the exposure time in this setup next time around.

Overexposed

If the plate goes black almost immediately (within 30–60 seconds), it is overexposed. Remove the plate at once from the developer and continue on to the next step in development. You may still have a hologram. Since the hologram is overexposed, make a note to decrease the exposure time in this setup next time around.

Typically the plate will gather density and may appear to turn completely black while it is lying in the developer solution. This is normal.

Remove the film from the developer, using the wooden photography tongs, and place it in the water tray for 15–30 seconds. The water tray step isn't mandatory, but it extends the life of the bleach solution for subsequent reuse.

After the water tray, place the film in the bleach tray, again using the tongs. Again rock the tray gently every 20–40 seconds. Keep the film in the bleach until it becomes completely transparent; this usually takes about 1 minute. When the plate clears, it is light safe. You can turn on standard room lighting now to finish development.

Leave the plate in the bleach and bring the water tray to a sink and start running cold water. Place the water tray in the running water. Remove the plate from the bleach, using the tongs, and place it in the water tray. Keep the plate under the running water for at least 5 minutes. Then remove the plate, stand it vertically against a wall, and allow it to dry. The holographic image will *not* be *visible* until the hologram is completely *dry*. Many people miss this point and believe they don't have a hologram when actually they do.

The holographic glass plate sometimes dries with water spots. To prevent this from occurring, dip the film in Kodak Photo-flo solution (mix according to directions) after the running water rinse.

Some holographers wipe the film with a squeegee to remove excess water and thereby speed up drying. Others use a hair dryer to shorten the drying time. If you should try to use a hair dryer, set the temperature to warm or low. Higher temperature settings may damage the hologram.

VIEWING YOUR HOLOGRAM

The film (glass plate) must be completely dry in order for you to see the image. If it's still wet or damp, you probably won't be able to see anything.

The hologram you produced is a white light reflection. As the name implies, it is viewable in white light. The best type of illumination for this hologram is a point light source, such as the sun.

If you don't see an image right away, move the lighting angle back and forth a few times. If you still do not see an image, rotate the hologram 90 degrees and try again. Do this a minimum of four times to check all possible lighting angles. If you catch an image but its perspective is wrong, you are probably looking at the real image. Flip the hologram over (180 degrees) and look again. Real and virtual images are explained a little later.

Tungsten halogen lamps are an excellent artificial light source for viewing holograms. Standard incandescent lamps can be used, but the image quality isn't as good. When using an incandescent lamp, notice that when you increase the distance of the hologram from the bulb, the image appears sharper. This happens because the lamp becomes more like a point light source as the distance increases.

To improve the quality of the playback image, put a black sheet of paper behind the hologram. To make this effect permanent, spray paint the back of the hologram black. Do this only with reflection holograms you want to display because once they're painted, you can't use them to make copy holograms.

NO VISIBLE IMAGE

If there is no image visible on your plate, go to the "Trouble-Shooting Holograms" section at the end of this chapter, and read the subsection on "No Image."

REAL AND VIRTUAL IMAGES

There are two types of images you can view with your white light reflection hologram: real and virtual. The most common example of a virtual image is the image that is reflected in a mirror; see Figure 3.14. To the observer, the reflected rays that appear to come from the virtual image do not actually pass through the image. For this reason, the image is said to be *virtual*.

The parallax and perspective of the virtual image in a hologram are observed to be correct. As you move your head from side to side or up and

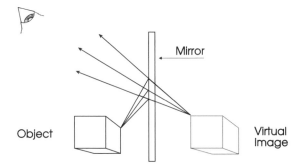

Figure 3.14. Holographic virtual image illustrated as mirror reflection.

down, the three-dimensional scene changes in proper perspective, as if you were observing the real physical scene; see Figure 3.15. The virtual image is said to be an *orthoscopic* or "true" image.

In contrast to the virtual image is the *real* image. The real image in your reflection hologram can be observed simply by flipping the hologram around. The real image has some peculiar properties. The perspective is reversed. Parts of the image that should appear in the rear are instead in the front, and vice versa. If you move your head to the right, the image appears to rotate in proportion to your movement and you see more of the left side, not the right side. The brain perceives this paradoxical visual information, causing the image to swing around. The real image is said to be *pseudoscopic*, meaning a false image. The real image is used when you want to make copies of holograms. I will cover making copy holograms in a later chapter.

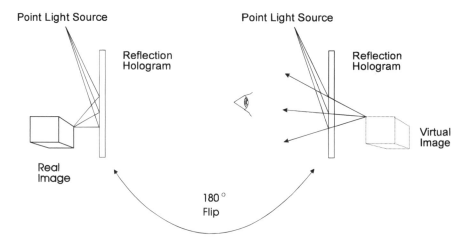

Figure 3.15. Holographic real image illustrated as a projection.

HINTS AND TIPS

1. In the illustrations the laser has been positioned on the isolation table. This is not necessary; you could move the laser off the table without any ill effects.

2. Try to keep the laser power supply off the isolation table. The 60-Hz hum from the step-down transformer may cause the table to vibrate, making it impossible to produce a hologram.

3. After you successfully produce a few holograms, you may want to try batch processing. Here you expose a few plates, keeping them in a light-safe box, and develop them all at once or one after another. The reason I don't advise doing this before you have successfully produced a hologram is that if there is something wrong with the setup, you'll be multiplying your errors with subsequent exposures.

4. Remember that the chemicals used to develop holograms are toxic; always wear rubber gloves when developing holograms.

MAKING A TEST STRIP EXPOSURE

A test strip exposure is commonly used in photography to determine the best exposure time for making a print. You can borrow this technique to determine the best exposure time for your reflection hologram.

Since light affects both sides of the plate, you need to build a small fixture to make test exposures on a plate.

The test strip fixture is illustrated in Figure 3.16. The dimensions given are approximate. This particular fixture is designed to be used with 2.5-inch-square glass holographic plates. The two sides of the fixture can be made from any opaque material: wood, plastic, etc. My fixture was made using two copper-clad phenolic boards I had lying around. The inside spacer must be thick enough so that the fixture can be slid over a standing glass plate.

When you have the two sides cut to size, hold them together, making sure the bottom edges are perfectly flush, then drill two holes in the top section for the 6-32 machine screws and nuts. Use the holes in one of the sides as a guide to drill the holes in the spacer. Assemble the three pieces, using the 6-32 machine screws and nuts. Finally, hot-glue or epoxy a small magnet to the bottom of one of the sides. This will prevent the fixture from moving during exposure.

Assuming that you have a single-beam setup on the table with a fresh holographic plate in position, place the test fixture over the holographic plate, allowing approximately 1/4 of the plate to show. You will make four consecutive exposures. After each exposure, you will move the fixture so that another 1/4 of the holographic plate shows; see Figure 3.17.

Make each exposure, using the technique described for making a reflection hologram. You hold the shutter card above the table for 30 seconds to let any vibration die out, then lift the shutter completely out of the way to make the exposure. After 5 seconds, place the shutter card back into position, move the fixture plate, and do the next exposure.

You develop the test plate the same way as described previously for the reflection hologram. When developing the test plate, look to see what

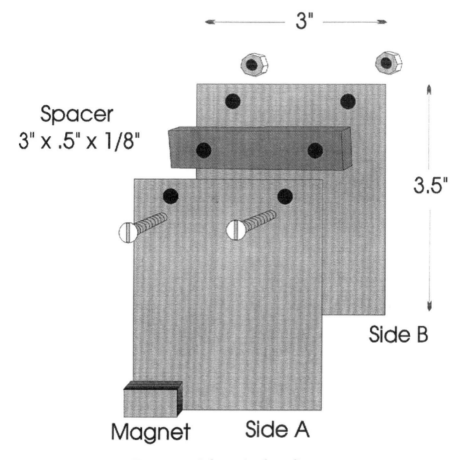

Figure 3.16. Schematic of test fixture.

strip has the best density after 2 minutes. Suppose you see that the 5-second strip has a density of 70% and the 10-second strip is completely opaque (100%). You can estimate that the optimum exposure time for this setup is going to be about 7.5 seconds. Continue the development process with the water bath and bleach. When the hologram has finished drying, you can look at the resulting test strip images; see Figure 3.18.

Aside from the density gathered during development, the best resulting holographic image on the test strip plate should be the determining factor for gauging exposure time.

SAVE THOSE BAD PLATES

Not every plate you shoot will produce a satisfactory hologram. Do not toss those bad plates; they still have some usefulness to them. First, clean

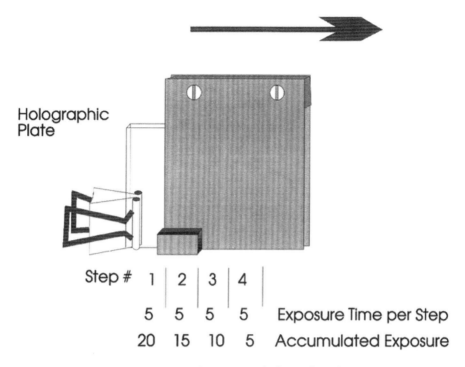

Figure 3.17. Test fixture over holographic plate.

the emulsion off of the plate, using a steel wool pad under running tap water. These glass plates are perfect "dummy plates" for positioning the holographic plate on the table when setting up. The dummy plate is the exact size of the holographic plate, so you can look through it to see exactly how the resulting hologram should look. In a pinch the plate can also be used as a 9:1 beam splitter.

TROUBLE-SHOOTING HOLOGRAMS

No Image

If the hologram has no image at all, you must look back to the development for a clue to what happened. First, did the hologram gather density in the developer? For reflection holograms, the density should be approximately 80% dark by eye. If the plate has the proper exposure (gathered density over the 2 minutes it was in the developer), you need to look for vibration or movement.

1. Try securing the model and plate better and re-shoot.
2. Check for vibration on the isolation table. Do a steadiness check of the isolation, if you haven't done so previously. See Appendix C, "Steadiness Check."

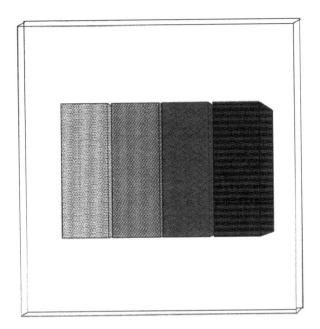

Resulting Test Strip Hologram

Figure 3.18. Finished hologram showing test strips.

Weak Image

Was the model placed close enough to the holographic plate? For single-beam reflection holograms, the model should be as close to the holographic plate as possible. If the model is positioned a few inches away you may not get an image, or if you do, it will be weak.

Weak images may also be caused by under- or over-exposed holographic plates. Exposure (under or over) can be determined during development. If you are sure the exposure is correct, another cause may be light leaks or an "unsafe" safelight.

To check for light leaks, turn off all illumination in the area in which you are shooting. Allow a minute or so for your eyes to become accustomed to the darkness. Then look around and see if you can find any light leaks.

To check the safelight to ensure that it is not degrading your images, take out a fresh holographic plate. Hold it under safelight illumination for a few minutes. Then throw the plate into the developer solution. If it turns black or gathers density, the safelight isn't safe.

Bands

Bands may be caused if the object or the plate moved slightly during exposure. To determine which moved, look to see where the bands are. If the bands are on the model, then it moved during exposure. Bands on the plate show that *it* moved during the exposure. To correct the problem, secure the plate or model more securely.

Overhead lighting— improving the single-beam setup

The single-beam holographic setup from the last chapter suffers from an obvious handicap: side lighting. To understand this, trace the spread beam of the laser to the holographic plate; see Figure 4.1. The point at which the spread laser beam first strikes the plate, A, becomes the top of the plate.

The reason this is so is that the light needed to reconstruct the holographic image must illuminate the finished hologram at the same angle that the spread laser beam did during exposure. Figure 4.2 illustrates a typical display mounting. When the hologram is hung on a wall, with a point light source illuminating it at a 45-degree angle, the brightest image playback will be with the plate oriented so that the object holographed appears on its side.

The impact this has on placing the model during exposure is important, as Figure 4.3 illustrates. If the model is placed right side up when shooting the hologram with side lighting, when placed in the best viewing position on the wall, it will appear on its side. To correct this problem, the model must be placed on its side when shooting a hologram with side lighting, with the top of the model pointed toward the "A" side of the plate; see Figure 4.4. This places the holographic image of the model right side up when the plate is mounted in a stand or on a wall for viewing.

COMPENSATING FOR SIDE LIGHTING

Mounting models for side illumination can be accomplished in a number of ways. The model can be glued to a steel plate, and placed on its side

Top View

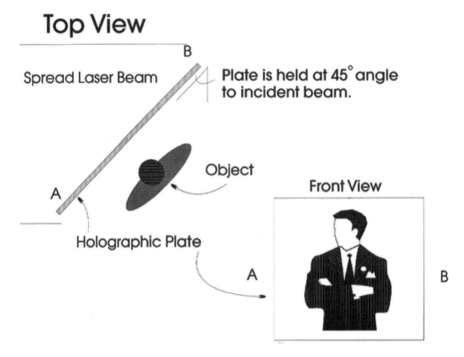

Figure 4.1. Spread laser striking holographic film plate; top view and front view.

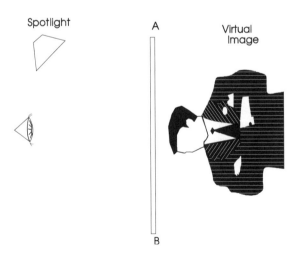

Figure 4.2. Spotlight illuminating a hung hologram.

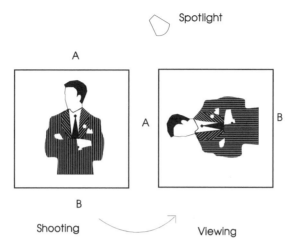

Figure 4.3. Shooting side illumination with model right side up and impact on viewing resulting hologram.

using magnets; see Figure 4.5. Another simple method is to glue the object to a transparent piece of plastic and secure it to the table using binding clips and magnets; see Figure 4.6.

You can use just about any type of glue that forms a strong bond. I use a two-part epoxy glue for permanent mounts, and a hot-glue gun for semi-permanent or temporary mounts.

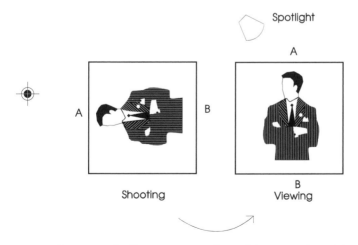

Figure 4.4. Shooting side illumination with model on its side and impact on viewing resulting hologram.

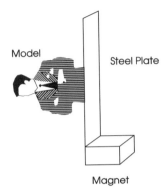

Figure 4.5. Model mounted to steel plate and secured to table using magnets.

OVERHEAD LIGHTING, METHOD #1

Materials needed:

Two front-surface transfer mirrors

One 10-inch-long steel plate

One jumbo magnet

One radius mirror

One holographic film plate with binding clip and magnet

One model

One shutter card

One white alignment card

One protractor

You can get around the problem of side lighting by using overhead lighting. Overhead lighting allows you to record the hologram of the model in its proper orientation. With overhead lighting, the laser light

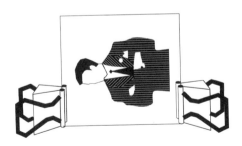

Model Secure on Plate

Figure 4.6. Model mounted to transparent plastic and secured to table using binding clips and magnets.

strikes the plate at a 45-degree angle from overhead; see Figure 4.7. For overhead lighting you need a few more components: two front-surface (FS) mirrors, one 10 × 1 × 1/16-inch steel plate, and one jumbo magnet.

The first FS mirror reflects the laser at a 45-degree angle. The second FS mirror reflects the laser up toward the radius mirror that is mounted on top of the 10-inch steel plate. The jumbo magnet secures the longer steel plate to the table. The radius mirror reflects and spreads the laser beam down to the holographic plate. The model is placed right side up behind the plate.

To check the plate position, use either a dummy glass plate or a white alignment card cut to the same size as a holographic plate. Make sure that the spread beam completely covers the holographic plate.

Checking the Angle

Use a protractor to check the angle of the incident beam. It is easy to misjudge the angle by eye. Figure 4.8 shows a protractor set for a 45-degree angle. You can use beam angles between 30 and 45 degrees. If the spread beam doesn't completely cover the plate, you can move the radius mirror

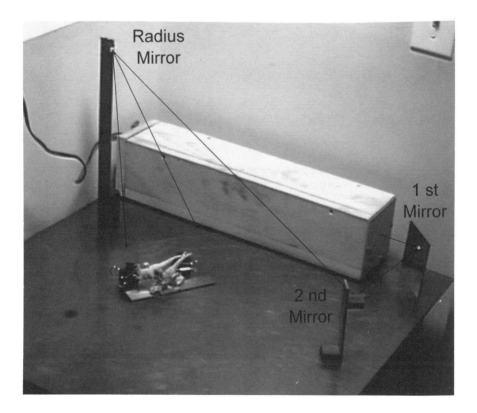

Figure 4.7. Overhead lighting using 10-inch steel plate, 2 transfer mirrors, jumbo magnet, and radius mirror.

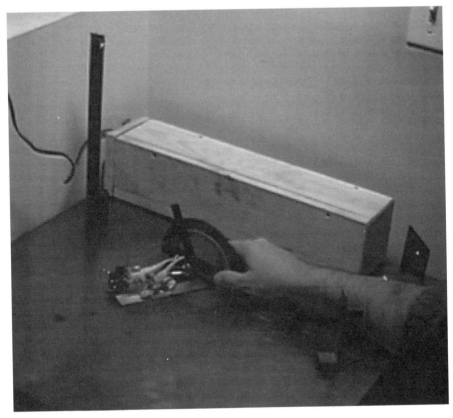

Figure 4.8. Protractor set to 45-degree angle.

up a little, or move the plate position a little farther away. Moving the plate will change the angle, but as long as you are between 30 and 45 degrees, you will be OK.

Loading the Holographic Plate

Turn off all standard room illumination. Turn on your safelight. Shutter the laser with the shutter card. Remove a fresh holographic plate and load it into position. Remember when loading the holographic plate into position to check for the emulsion side. The emulsion side should face the model being holographed.

Exposure Times

Assuming that you are using a radius mirror with the laser beam spread to a diameter of approximately 3 inches, use the following exposure times as a start.

EXPOSURE TIMES

Laser Power	Exposure Time
1-milliwatt laser	6 seconds
1.25-milliwatt laser	5 seconds
2.5-milliwatt laser	3 seconds
5-milliwatt laser	1.5 seconds

If you are using the steel spherical mirror, double the exposure times.

To gauge the best exposure time for your hologram, you will need to make a test exposure strip on a holographic plate, as explained in Chapter 3.

If you already made a test exposure strip in Chapter 3, you can use the best exposure time for this setup. Expose the hologram using the shutter card, as described in Chapter 3.

Development

Develop and view the hologram as described in Chapter 3.

Improving the Hologram

When laser light strikes the holographic plate, the edges of the plate deflect some of the incident light, creating a slight degradation (*diffraction*) in the finished hologram. This degradation is seen as a slight rainbow effect in the hologram, caused by the recording of the diffracted light and the reference beam (and/or object beam).

To prevent this from happening, paint the edges of the holographic plate black, using a permanent-ink black magic marker. During development some of the ink may come off, making little black floaters in the solution. So far these floaters have not caused me any development problems, and the solutions are still reusable.

Painting the edges of the glass holographic plates black before shooting will also improve the quality of all holograms, regardless of the particular setup.

IMPROVING MODEL AND PLATE STABILITY WITH OVERHEAD LIGHTING

Using the overhead lighting it is possible to lay the model flat on the table; see Figures 4.9 and 4.10. The holographic plate is supported off the table above the model, using magnets. This arrangement provides excellent stability for the holographic plate and model.

Materials needed:

Two front-surface transfer mirrors

One 10-inch-long steel plate

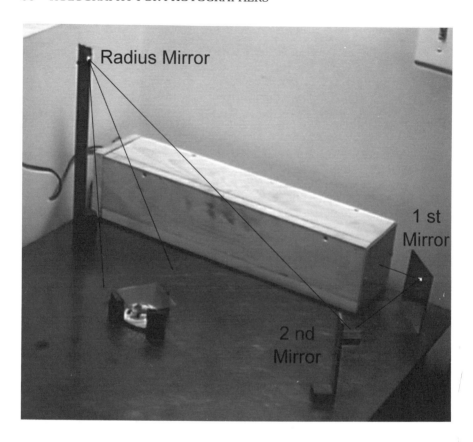

Figure 4.9. Diagram of incident beam striking holographic plate and model laid flat on table.

One jumbo magnet

One radius mirror

One holographic film plate

Three square magnets

One piece of clay or Fun-Tak (small amount)

One model

One shutter card

One white alignment card

One protractor

To ensure maximum stability, the model should be secured to the table. The model can be secured to the table in any number of ways. For instance, hot-glue a magnet to the model, then secure the magnet to the

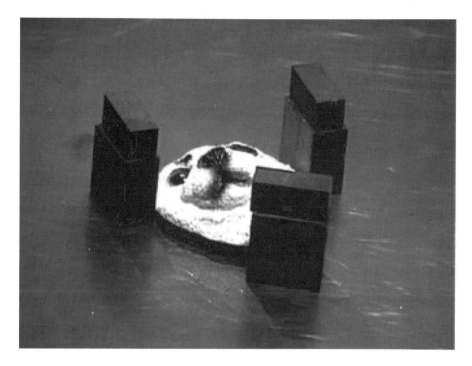

Figure 4.10. Photograph of model and plate laid flat on table.

table, or hot-glue the model directly to the table. If the model has some weight to it, the weight of the object itself will ensure that it doesn't move during exposure.

Position the three magnets around the model. Use a dummy plate to check that the plate will rest comfortably on the magnet tops. Place a white alignment card on top of the magnets and direct the spread beam from the radius mirror onto the card. Align the beam so that the card is evenly lit with the laser light.

To secure the glass holographic plate to the magnet tops, make three small balls (3/16-inch diameter) of clay and place them on top of the magnets where the holographic plate touches the magnets; see Figure 4.11. When loading the plate onto the assembly, place the plate on the clay balls and press down firmly, squashing the clay flat; see Figure 4.12. Do not readjust the holographic plate or it will not be secure. If the plate must be readjusted, remove it from the magnets, taking care to remove all the clay. Re-ball the clay and place it back onto the magnets and place the plate down again.

Exposure Times

Assuming that you are using a radius mirror with the laser beam spread to a diameter of approximately 3 inches, use the following exposure times as a start.

Figure 4.11. Clay balls on magnet waiting for holographic plate.

EXPOSURE TIMES

Laser Power	Exposure Time
1-milliwatt laser	6 seconds
1.25-milliwatt laser	5 seconds
2.5-milliwatt laser	3 seconds
5-milliwatt laser	1.5 seconds

If you are using the steel spherical mirror, double the exposure times. Expose the hologram using the shutter card as described in Chapter 3.

Development

Remember to remove all the clay from the plate before processing! Develop and view the hologram as described in Chapter 3.

When using single-beam overhead lighting, this is the preferred method. Note that the top of the plate is facing the overhead lighting fixture. To prevent any diffraction degradation from the edge of the

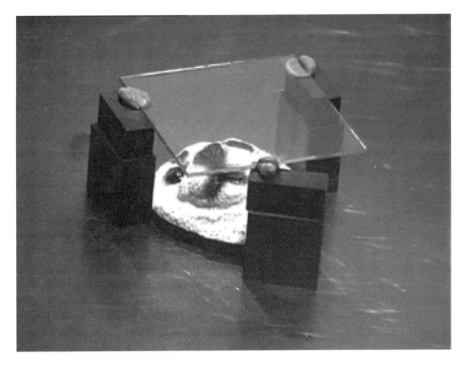

Figure 4.12. Holographic plate secured to magnets.

holographic plate, you should paint the edges of the holographic plate black.

OVERHEAD LIGHTING, METHOD #2

Another way to achieve overhead lighting is to use side lighting and tilt the holographic plate toward the spread laser beam at an angle of 45 degrees. This allows you to use the side lighting setup and trick the plate into seeing an overhead light. To perform this function easily and accurately with minimum fuss, it is best to make a small fixture.

The fixture allows you to quickly set up a simple reflection hologram with an optimal reference beam angle.

Fixture

The fixture illustrated in Figure 4.13 is multipurpose. It can be used to create holograms as well as make image place reflection copies.

The sides of the fixture are made from 1 × 4-inch lumber. Lumber is usually a little smaller than the size it is called; for instance, 1 × 4 lumber's actual size is 3/4 inch thick by 3 1/2 inches wide. Cut one end of the lum-

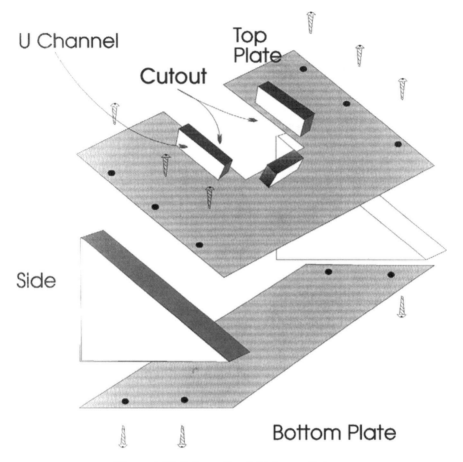

Figure 4.13. Schematic of 45-degree fixture.

ber at a 45-degree angle. This cut can be made accurately using a miter box. A miter box has slots to fit a saw for standard angles as well as straight cuts.

The piece you first cut is the first side. Now use a straight cut to remove the 45-degree angle left on the original piece of wood. This becomes the second side.

I made the top of the fixture out of some copper-clad board I had lying around. Its size is 6 × 4 7/8 inches. However, you can use just about any rigid material, for instance 3/16-inch plywood, 1/8–1/4-inch plastic, or 3/32-inch sheet metal.

Cut a channel out of the top piece of the fixture. The width of the channel should be a little smaller than the plate it needs to hold, in this case approximately 2.25 inches (to hold a 2.5-inch-square holographic plate). When the holographic plate is placed in the fixture channel, each side of the plate will be supported by a 1/8-inch lip. The overall channel size is 2 1/4 inches wide by 3 1/2 inches deep.

The bottom plate of the fixture is needed to make the fixture rigid and strong. I also made this out of some copper-clad board. Its overall size is 3.5 × 6 inches.

The top and bottom plates are secured to the side using small wood screws. Drill holes in the top and bottom plates for the screws. Use these holes to mark the hole positions on the sides with a pencil. Drill small pilot holes for the wood screws to prevent splitting the wood.

The outer channel on the top section is made out of three pieces of 1/2 × 3/4-inch wood. Each piece of wood is a side of the U channel. The wood is secured to the top plate using hot-glue. If you have a discarded holographic plate from a previous channel, place it on top of the channel so that there is a 1/8-inch lip on each side and the bottom. Next, position the 1/2 × 3/4-inch wood next to the glass plate on the top plate and glue it into place.

The 1/2-inch side of the wood is glued to the surface, leaving the 3/4-inch side protruding up. You may question why you are using such a large thickness of wood to hold the holographic plate in position. You could just as easily use a 1/8-inch-thick piece of material. If the only thing you were using the fixture for was to hold a plate for making holograms, that would be fine. To use the fixture for making image plane copies, a thicker channel is more desirable; you will see why later.

Make sure you can move a plate in and out of the U channel easily. Don't position the wood so close that it binds the plate in; this will create problems. Figure 4.14 is a photo of the completed fixture.

Model Fixture

The holographic plate fixture holds the plate at a 45-degree angle to the incident beam. If you placed your model upright behind the plate, the top of the model would be farther from the plate than the bottom. When you viewed the finished hologram, it would appear as if your model were leaning back. In addition, the bottom of the model would be brighter and in clearer focus because of its closer proximity to the plate, while the top of the model would be duller and less focused.

To correct this, you need a simple model fixture that will hold the model at a 45-degree angle. With the model held at a 45-degree angle, it will be parallel to the holographic plate and the entire model will holograph much more clearly.

The model holder is a piece of 1 × 4 lumber with a 45-degree angle; see Figures 4.15 and 4.16. You have the option of attaching models directly to the model holder. I glued a strip of 1 × 5 × 1/16-inch-thick steel plate to the front. Next, glue a strong magnet to the model you will holograph. The models are held to the steel strip on the model holder by the magnet. This arrangement allows you to move the model up or down and angle it left or right to achieve the best lighting and composition.

Since the model holder is front heavy, especially with a model attached, you must place a magnet or magnets on the side or back of the 1 × 4-inch wood to prevent it from toppling forward. Figures 4.17A and B show a typical setup.

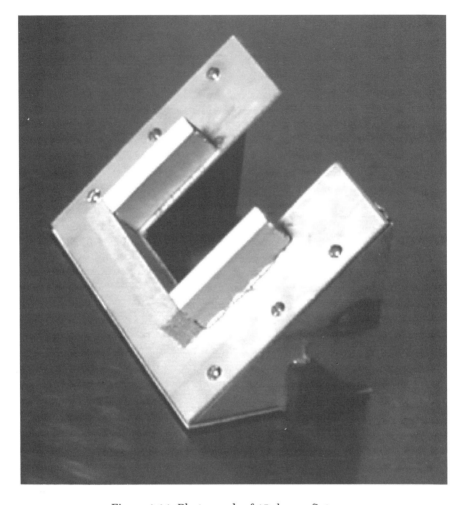

Figure 4.14. Photograph of 45-degree fixture.

Setup

This holographic setup is made easy because of the two fixtures involved. The added advantage is that the reference beam will always be at an optimum 45 degrees.

 Materials needed:

One radius mirror with magnetic mounting

One 45-degree holographic plate fixture

One 45-degree model fixture

One holographic plate

One model

Steel Plate

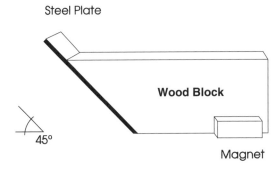

Figure 4.15. Drawing of 45-degree model-holding fixture.

One white alignment card

One black shutter card

Place the radius mirror so that it intercepts the laser beam and reflects the spread beam diagonally across the table. Position the 45-degree fixture in the center of the table, facing the radius mirror. Place a white alignment card inside the 45-degree fixture where the holographic

Figure 4.16. Photograph of 45-degree model-holding fixture.

Figure 4.17A. Single-beam reflection holographic setup using plate and model fixture.

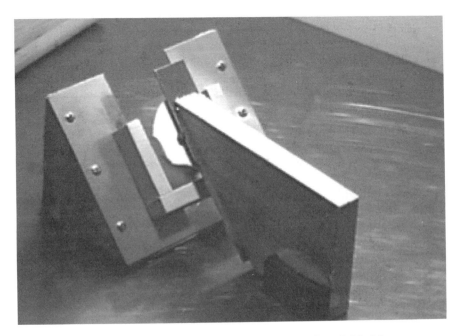

Figure 4.17B. Close-up of 45-degree fixture and model holder.

plate will be put. The spread beam from the radius mirror should strike the card/fixture directly (90 degrees perpendicular).

Align the radius mirror so that a clean spread beam evenly illuminates the white alignment card. If the spread beam doesn't cover the card completely, move the fixture farther away until it does.

Replace the white alignment card with a dummy glass plate. Position the model as close to the plate as possible. Remove the dummy plate, turn on the safelights, and turn off any standard room lights. Shutter the laser.

Exposure Times

If you are using a radius mirror with the laser beam spread to a diameter of approximately 3 inches, use the following exposure times as a start.

EXPOSURE TIMES

Laser Power	Exposure Time
1-milliwatt laser	6 seconds
1.25-milliwatt laser	5 seconds
2.5-milliwatt laser	3 seconds
5-milliwatt laser	1.5 seconds

If you are using the steel spherical mirror, double the exposure times. Expose the hologram using the shutter card as described in Chapter 3.

Development

Develop and view the hologram as described in Chapter 3 for reflection holograms.

WHY USE SIDE LIGHTING IF OVERHEAD LIGHTING IS BETTER?

As you continue, you will be using a lens to collimate the reference beam. To maximize component stability, it is easier to have the components lie flat on the table, using side lighting rather than overhead lighting. In addition it is easier to match the path distances with a beam that is parallel to the table. All this will become evident when I cover those procedures later on.

LIGHT LOSSES AND MINIMUM COMPONENTS

Each time the laser beam is reflected from an FS mirror, a small amount of light intensity (approximately 8%) is lost. The simple arrangement used for overhead lighting for single-beam reflection uses three reflecting surfaces. This doesn't have too much impact on the exposure time. However,

when you are working with complex split-beam setups, the number of mirrors in each beam path can add up, requiring a longer exposure time than you may have originally estimated.

You should always strive to minimize the components used on the table. Aside from the light losses, each component used brings with it its own risk that it may move or become misaligned at the last moment, ruining a potentially good hologram. So if you can do without a particular component on the table, do so.

DIRECT REFLECTION COPIES

Suppose you've shot a hologram that came out very nicely. You've shown it around to your friends and someone asks you to make him or her a copy. Well, you could set up the table again and re-shoot, or you could make a *direct reflection copy*.

The standard notation for the master hologram (the one you are making a copy of) on an illustration, diagram, or schematic is H1. H2 is the standard notation for a copy plate.

Making reflection copies is easy. Figure 4.18 illustrates the basic setup. H1 is placed in the spread beam, angled to produce the brightest image. Two magnets and clips, one on each side of H1, are used to secure the H1 plate in the proper position and angle. In this particular case, side lighting is preferred because it is easy to adjust the angle of H1 to the incident beam to produce the brightest image.

Setup

Materials needed:

One radius mirror

One H1 hologram

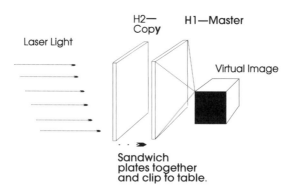

Direct Reflection Copy

Figure 4.18. Direct reflection copy setup.

One holographic plate (H2)

One white alignment card

One black shutter card

Figure 4.19 shows the table setup to shoot a direct reflection copy. The radius mirror is positioned to intercept the laser beam and reflect the spread beam across the table. Use the white alignment card to determine whether the beam is spread evenly across the plate without any imperfections. Remove the white alignment card and secure the H1 hologram at this position. Angle the H1 hologram in the spread laser beam to the angle that produces the brightest image. Secure the position by using a binding clip and magnet on each side of H1.

Block the laser with the shutter card. Turn on the safelight(s) and turn off all standard room illumination. Take out a fresh holographic plate (H2) and sandwich it in front of H1, using the two binding clips.

Typically the exposure time for making a copy is approximately the same exposure time needed to make a single-beam hologram. Make the exposure as you have done previously. Lift the shutter card off the table, holding it just above the table so that it still blocks the laser beam. Hold it in this position for about 30 seconds to allow any vibrations to die out. Then lift the card out of the beam path for the determined exposure time.

Develop the copy hologram as before. When it has dried completely, you should have an exact copy of the original.

COLLIMATED REFERENCE BEAM

The laser light you have been using thus far has been diverging sharply from a lens or radius mirror. In many cases it is preferable to use a *colli-*

Figure 4.19. Direct reflection copy setup.

mated beam. What is a collimated beam? When a beam is collimated it is no longer diverging outwardly into space; rather, the beam stays the same size, traveling roughly parallel through space. No collimation is perfect—the traveling light beam will eventually diverge—but this is not a concern for us. On the isolation table, for all intents and purposes, the beam can be considered perfectly collimated.

There are a few methods open to you for collimating the laser light. One method uses a large parabolic mirror, similar to the small radius mirror, only much larger. When you place a diverging optic (radius mirror, negative lens, or positive lens) at the focal point of the large parabolic mirror, the light reflected from the large mirror becomes collimated; see Figure 4.20.

Another method, and the one you will use, is to use a positive lens; see Figure 4.21. The positive lens can be a plano-convex or a double convex. Since the holographic plates you are using are 2.5 inches square, you can get away with using a lens that is a little bigger than the plate itself.

The main consideration in choosing a lens is that its focal length (FL) is long enough so that the radius mirror spreads the laser light to a point where it completely covers a holographic plate; see Figure 4.22.

Setting Up the Lens

Set up the table to shoot a single-beam reflection hologram, using the 45-degree fixture. Begin by placing the radius mirror on the table so that

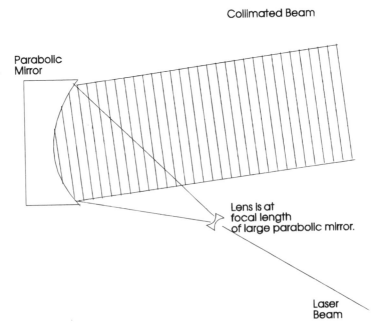

Figure 4.20. Collimated beam produced from large parabolic mirror.

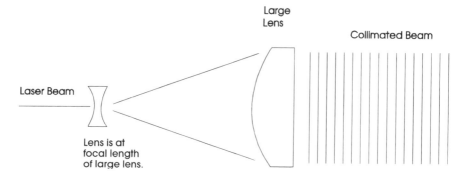

Figure 4.21. Collimated beam produced from positive lens.

it intercepts the laser beam and reflects the spread beam diagonally across the table. Place the collimating lens in front of the diverging beam. If you know the focal length of the lens, place it at that distance from the diverging optic.

Always check the resulting beam to make sure it is collimated. An easy way to check is to hold a white card behind the lens. Move the card toward and away from the lens. The outline of light shining on the white card should remain the same (not get bigger or smaller). If it does change size, the lens is not in the proper position. Move it toward or away from

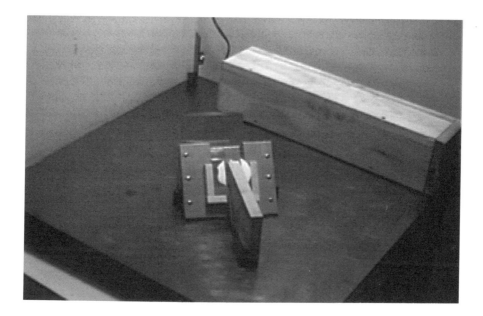

Figure 4.22. Single-beam reflection setup with collimated beam.

the diverging optic and check it again. When the outline stays completely stable, continue setting up the table.

Place the fixture on the table so that the collimated beam will illuminate the holographic plate. Place a white alignment card into the 45-degree fixture. Check the spread beam to ensure that it is covering the card completely. Remove the white alignment card and place a dummy glass plate in the fixture. Place the model behind the plate position. Remove the dummy glass plate. Turn on the safelight and turn off standard room illumination. Shutter the laser and load the fixture with a fresh plate.

Exposure Times

If you are using a radius mirror with the laser beam spread to a diameter of approximately 3 inches, use the following exposure times as a start.

EXPOSURE TIMES

Laser Power	Exposure Time
1-milliwatt laser	6 seconds
1.25-milliwatt laser	5 seconds
2.5-milliwatt laser	3 seconds
5-milliwatt laser	1.5 seconds

If you are using the steel spherical mirror, double the exposure times. Expose the hologram using the shutter card as described in Chapter 3.

Development

Develop and view the hologram as described in Chapter 3 for reflection holograms.

Checking the Finished Hologram

When you look at the virtual image of this hologram, it will look like any other hologram shot with a diverging beam. When you look at the real image, by flipping it over, the difference is very noticeable.

Reflection holograms shot with a diverging beam have a real image that is a magnified projection of the model, in contrast to a reflection hologram shot with a collimated beam, which has a real image projected at the same size as the virtual image.

The real image of a hologram is used to make a number of different types of copy holograms. To make undistorted copies requires an undistorted real image. This is why it is necessary to collimate the beam. You can use the hologram you just made to make an image plane hologram.

IMAGE PLANE COPY HOLOGRAM

To make an *image plane* hologram, you project the real image from the master onto an unexposed plate. The advantage this technique has over the direct reflection copy is that you can move the plane of the holographic image, meaning that you can move the holographic image in front of, bisect, or move it behind the holographic plate. If you have ever viewed a hologram where the image is projected in front of the plate, rather than behind it, this is one way you can accomplish this.

Figure 4.23 shows the basic setup. H2 (the copy) is placed in front of H1 (the master). The real image from the master is projected forward toward H2.

Setup

Materials needed:

One radius mirror with magnetic mounting

One 45-degree holographic plate fixture

One H1 hologram (master)

One holographic plate (H2)

One white alignment card

One black shutter card

One large positive lens

The procedure for making an image plane copy is as follows. Use the radius mirror to spread the laser beam diagonally across the table; see Figure 4.24. Place the positive lens in front of the spreading beam to collimate the beam. Check the beam to ensure that it is collimated.

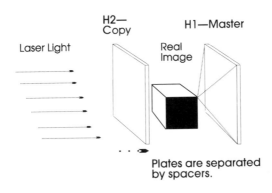

Image Plane Copy

Figure 4.23. Schematic of image plane setup.

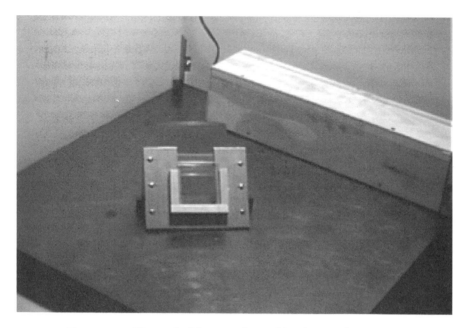

Figure 4.24. Photo of table setup for making image plane copy.

Position the 45-degree fixture so that it intercepts the collimated beam directly.

Start by placing a white alignment card in the 45-degree fixture holder. Check the spread beam to make sure that the beam is evenly illuminating the white card. Remove the white card and replace it with a dummy glass plate. The dummy glass is necessary to accurately gauge where the fresh plate (H2) will be positioned. At this point you can add spacers behind the glass to vary where the real image will bisect the copy plate. If you do not use spacers, chances are that the entire image will be projected behind the plate of the image plane copy (just like the original). In many cases, holographers make the image bisect the plate, allowing half of the image to project in front of the plate and the rest of the image to project behind the plate. See the closeup in Figure 4.25.

Spacers can be made from the same wood used to make the U channel on the 45-degree fixture (1/2 × 3/4 inch). Cut a 1 1/2-inch length of this wood; then, using a sharp knife, split the wood into four equal pieces along the 3/4-inch thickness; see Figure 4.26.

If you use the spacers, place one spacer on each side and one on the bottom of the glass plate in the 45-degree fixture. Next, place the master hologram on top of the spacers, so that the real image is being displayed.

To produce the brightest real image from the master H1, you will have to tilt the plate slightly. Rather than tilt the plate itself, tilt the entire 45-degree fixture. At the angle at which it produces the brightest real image, place spacers under the fixture to hold the fixture at that angle.

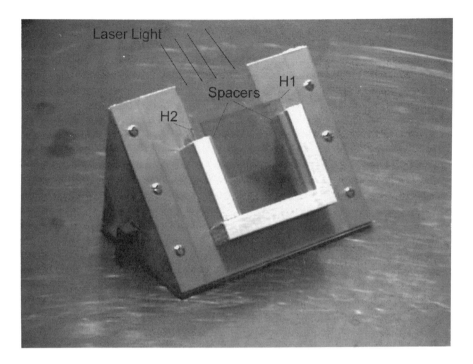

Figure 4.25. Labeled photograph of 45-degree fixture.

Making the Exposure

Remove the master H1 from the 45-degree fixture; note the orientation when you take it out and put it down. You must reload this plate exactly as it was, or you will not make a copy hologram. Next, remove the spacers and the dummy glass plate.

Shutter the laser, turn off the room lights, and turn on the safelights. Load a fresh holographic plate (H2) into the fixture. Next, put the spacers on top of the H2 plate. Finally, replace the master hologram in the fixture, making sure it is oriented properly.

You may want to place a little clay on the top corners of H1 to secure it in position. Make your exposure using the shutter card.

Use the same exposure time that you used to make the master hologram. Develop for a reflection hologram as before.

Results

When you look at the copy hologram, at first it may look like the original. Look closely and you will notice that the holographic image is being projected in front of (or bisecting) the holographic plate.

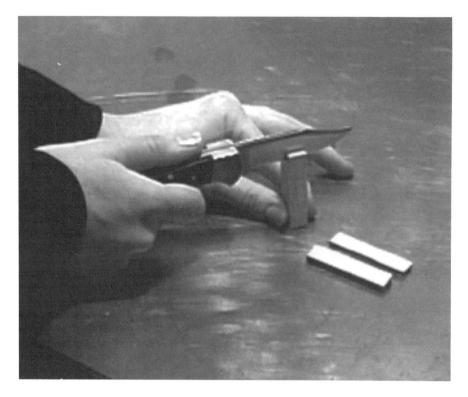

Figure 4.26. Photo of knife splitting 1/2 × 3/4-inch wood.

Transmission holograms

Transmission holograms are the granddaddy of holography. They were the first type of hologram developed that is still recognized today as holography. Emmett Leith and Juris Upatnieks developed transmission holograms at the University of Michigan in the early 1960s. They developed the off-axis reference beam that improved the holographic image playback.

SINGLE-BEAM TRANSMISSION HOLOGRAMS

In this chapter you will make a simple single-beam transmission hologram. Before you do so, let's examine the particular differences between shooting transmission holograms and shooting reflection holograms.

Primarily, when you are shooting a transmission hologram, both the object beam and the reference beam affect the holographic plate on the same side; see Figure 5.1. When you are shooting a reflection-type hologram, the object beam and the reference beam affect the holographic plate from opposite sides; see Figure 5.2.

When shooting single-beam reflection holograms, the operation of the reference and object beams may not be obvious, so let's look at this now before proceeding. The spread laser beam, as it first strikes the holographic plate, constitutes the reference beam. After the beam travels through the transparent plate it strikes the object. The reflected laser light off the object going back toward the plate becomes the object beam; see Figure 5.3.

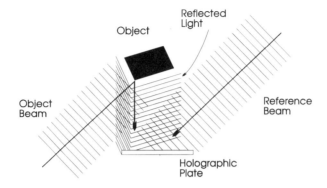

Making a Transmission Hologram

Figure 5.1. Transmission hologram; both object beam and reflection beam strike the holographic plate on the same side.

SHOOTING A SINGLE-BEAM TRANSMISSION

Materials needed:

One radius mirror

One holographic plate with binding clip and magnet

One ND filter

One 3 × 3-inch FS mirror

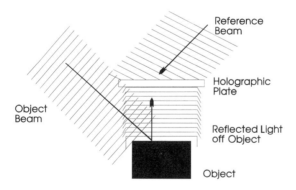

Reflection Hologram

Figure 5.2. Reflection hologram; reference beam and object beam strike the holographic plate from opposite sides.

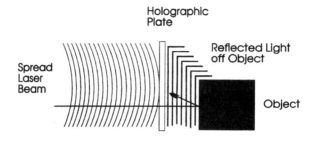

Single-Beam Reflection Hologram

Figure 5.3. Single-beam reflection hologram, illustrating the reference beam and object beam.

One model

One white alignment card

One shutter card

You will need two additional components: a 3 × 3-inch front-surface mirror with a bar magnet glued to the bottom of one side, and a small piece (1 × 1 inch) of neutral-density (ND) or polarizing filter material. While it is possible to shoot a transmission hologram without these materials, I have found the results less than satisfying. This particular setup can almost be considered a split-beam from the way you are configuring the components.

ND Filter

Neutral-density (ND) filters reduce the intensity of the light passing through them. ND filters are expensive; if you decide to purchase one, buy a .5 ND filter.

In place of an ND filter, you could use a *polarizing* filter. The polarizing filter will also reduce the amount of light passing through it. However, you must be aware of a few facts. If you are using a polarized laser, the polarizing filter can vary the intensity of the beam passing through by rotating the filter material in the beam. At a particular point, the polarizing filter may cut off the beam completely. If you have a polarized laser, rotate the Polaroid® filter material until approximately 50% of the light is passed through.

If the laser you are using is unpolarized, the Polaroid material will reduce the beam intensity by about 50% regardless of its orientation.

You can also make an ND filter with film. Place an unexposed holographic plate in developer solution. Turn on the room lights for 1–2 seconds. Let the film develop until its density is about 50%. Remove the glass plate from the developer solution and rinse in tap water for about 5 min-

utes. Do not bleach the plate. When you hold the plate up to a light you will see that it is semi-transparent, with an even density.

SINGLE-BEAM TRANSMISSION SETUP

The setup is shown in Figures 5.4 and 5.5. Position the radius mirror so that it intercepts the beam directly from the laser and is angled at 45 degrees across the table. The ND filter is held in a binding clip secured with a magnet to a steel plate, which is secured to the table. Position the ND filter on the left side of the spreading beam path so that it intercepts half of the spreading laser beam from the radius mirror.

Place a large white card in front of the spreading beam; you will see that as the laser beam passes through the ND filter, it loses a portion of its intensity. Another way of saying that you decreased the intensity of the beam is to say that you *attenuated* the beam. This lower-intensity portion of the laser beam will become your reference beam.

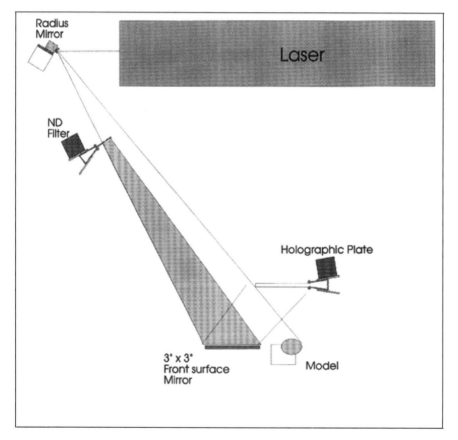

Figure 5.4. Schematic of single-beam transmission hologram setup.

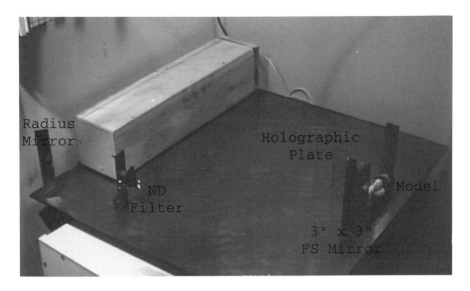

Figure 5.5. Photograph of single-beam transmission hologram setup.

Why Use an ND Filter?

Ideally, when shooting a transmission-type hologram, you try to achieve a beam ratio of 4:1 (reference beam to object beam). Therefore, you want the light intensity of the reference beam to be about four times greater than that of the object beam. The ND filter reduces the intensity of the reference portion of the single beam. This may at first appear counter-indicated, but it is not; here's why.

Although the object is being lit with the full intensity of the laser light, it is only the light reflected off of the object that strikes the holographic plate to create the hologram. It is the reflected light from the object that is used to determine the object beam intensity. Naturally, the reflected light from an object has much less intensity than the direct beam illuminating the object.

The reference beam, because it's a direct light, is approximately ten times greater than the object beam. Therefore, using the ND filter to reduce the reference beam's intensity only serves to bring it closer to the 4:1 ratio you are looking for.

Model Position

Choose a light-colored model, smaller than the overall size of the plate. Use any one of the model-mounting techniques described previously: magnet, clay, or plastic.

Position the model on the right-hand side of the spread laser beam. The model should be evenly lit with the unattenuated side of the laser

beam. Much depends upon the physical dimensions of the model and how well it is lit with a 45-degree illuminating beam. You may want to try lighting a few different models and choose the one that lights the best.

Holographic Plate Position

Position a dummy glass plate about 2 1/2–3 inches in front of the model. Position a large white card behind the model. Make sure the dummy plate doesn't cast a shadow on the model. If it does, it means that unattenuated light from the spread beam is striking the plate. You do not want this to happen. Reposition the model and holographic plate (by moving both to the right) until the plate does not cast a shadow on the model. As you move the plate and model to the right, you may need to realign the radius mirror and reposition the ND filter.

Mirror Position

The attenuated beam (low-intensity portion) is reflected off the 3 × 3-inch mirror. Position the mirror next to the model's left side; the front of the mirror should be even with the front of the model. It's important that the mirror doesn't reflect any of the unattenuated beam to the plate. Use the large white card in front of the mirror to check this.

Place the white card behind the dummy plate. The mirror is angled so that it reflects light toward the holographic plate. The holographic plate should be evenly illuminated with reflected light.

Measuring the Distance

It isn't necessary to measure distances with this setup, but you will do so anyway as an exercise.

When you measure distances, it isn't necessary to know the absolute distance in inches, feet, yards, millimeters, centimeters, or meters. What is important is that the two beam paths you are measuring are equal. To measure distance you can use a piece of string or wire, or a cloth tape measure. I use a piece of stranded 22 GA. wire, because I can put a kink in the wire to mark a distance. The wire can be reused for another setup by wiping the kink out of it.

Using a string or wire, measure the distance from the center of the radius mirror to the center of the model, as shown in Figure 5.6. If you are using a wire, you can put a kink in the wire to mark its length. Using the kink in the wire as a starting point, measure the distance from the center of the model to the center of the holographic plate. Put another kink in the wire to mark this distance. The second kink marks the combined length; let's call this combined length "A."

Remove the first kink in the wire.

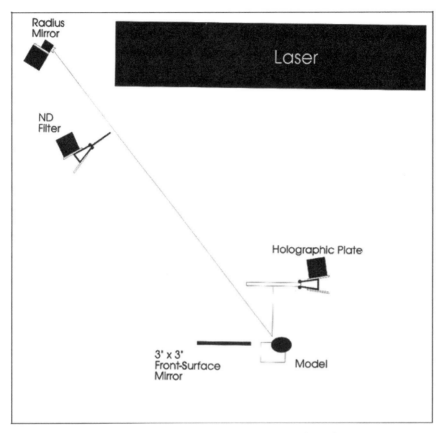

Figure 5.6. Measuring the distance of the object beam.

Next, measure the distance of the second beam path. Starting with the same end of the wire you used to measure the first beam path, measure from the center of the radius mirror to the 3 × 3-inch mirror. Put a small kink in the wire. Using this kink as a starting point, measure from the 3 × 3-inch mirror to the holographic plate; see Figure 5.7. The second kink in the wire should be pretty close to the holographic plate. Any difference in the length you just measured and the second kink in the wire is the difference in the beam lengths. They should be very close.

A Few Hints

If your beam path lengths appear to be off by more than an inch, here are a few hints that may explain why. When measuring the distance from the radius mirror to the 3 × 3-inch mirror, position the string or wire in the center of the beam that ends up illuminating the plate. Do not arbitrarily use the center of the 3 × 3-inch mirror as a measurement point,

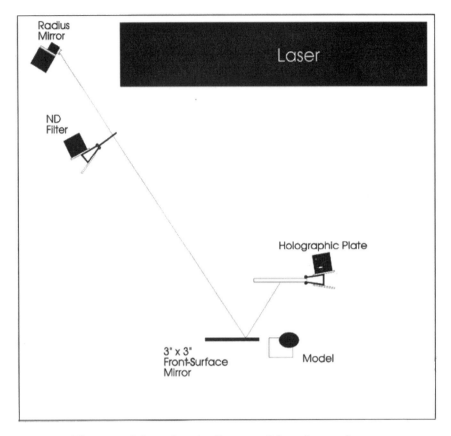

Figure 5.7. Measuring the distance of the reference beam.

unless of course that is where the center of the beam illuminating the plate is located.

When measuring from the radius mirror to the model, measure to the center of the model. The center of the model lies on the front plane. Not measuring to the internal center of the model will throw the measurement off.

Exposure Times

When the setup is satisfactory, place the shutter card between the radius mirror and the ND filter. Turn off any room lights and put the safelight on. Remove a fresh holographic plate and place it in the binding clip on the table.

The procedure for shooting the transmission hologram is the same as for shooting the reflection hologram. Lift the shutter card off the table, but still keep the beam blocked. Hold this position for about 30 seconds,

to allow any vibrations to die out, then lift the card completely for the allotted exposure time.

Assuming that you are using a radius mirror with the laser beam spread to a diameter of approximately 5 inches, use the following exposure times as a start.

EXPOSURE TIMES

Laser Power	*Exposure Time*
1-milliwatt laser	14 seconds
1.25-milliwatt laser	12 seconds
2.5-milliwatt laser	6 seconds
5-milliwatt laser	3 seconds

If you are using the steel spherical mirror, double the exposure times.

To gauge the best exposure time for your hologram, you will need to make a test exposure strip on a holographic plate. The procedure and materials needed to make a test strip are at the end of Chapter 3.

Development

When you are developing transmission holograms, the density of the plate should be around 15–20% dark by eye. Therefore, when you look through the plate, it is still transparent.

Materials needed:

Developer solution

Bleach solution

Water

Three trays

Tongs

Rubber gloves

Safelight

Watch or timer

To develop, use the same procedure as for the reflection hologram: 2 minutes in the developer (rock or move the plate every 30 seconds), 30 seconds to 1 minute in the water bath, then in the bleach until clear. Once the plate turns clear in the bleach, the hologram is light safe. At this point, the room lights can be turned on and the plate placed in running water for 5 minutes to remove all traces of development chemistry.

Remember, the single difference is that the density of the plate should only reach about 20% by eye in the developer. The plate will still appear semi-transparent when you look at a safelight through it.

VIEWING THE FINISHED HOLOGRAM

After development, it's time to take a look at the hologram. If you view the hologram under white light, you will see a color smear and diffuse image. To really see a transmission-type hologram, you must view it under a monochromatic light source like laser light. Place it back on the table in the binding clip. Remove the ND filter from the table so that you get a brighter beam.

The hologram needs to be put back the same way it was recorded. As with the reflection hologram, if you don't see any image at first, vary the angle back and forth a bit. If that doesn't work, rotate the hologram 90 degrees and try looking again. Rotate and look four times so you've looked at it from every orientation.

The transmission hologram has a real and a virtual image, like the reflection hologram. So if the image is there but looks wrong, you are probably looking at the real image. Flip the hologram over to look at the virtual image.

PROJECTING THE REAL IMAGE

The real image of a transmission hologram can be projected in front of the hologram. To see this, place the hologram on the table in the binding clip so that you can see the "real" image. Vary the angle of the hologram and find the angle that produces the brightest image.

Get a piece of tracing paper or frosted glass and move it toward the hologram. The spread beam from the laser that is illuminating the transmission hologram should not fall onto the tracing paper or frosted glass; the direct lighting will overpower the projected image, making it impossible to see. If necessary, move the hologram to the outer edge of the spread beam or place a light block at the outside edge of the hologram.

As the paper moves closer, you will reach a point where you can see the holographic image projected onto the paper. If you continue to move the paper closer, you can bisect the image. This hints at the way you can make reflection copies from a transmission hologram, but I will cover this in another chapter. As you move the paper closer, it becomes impossible not to intercept the illuminating beam.

ADVANTAGES OF TRANSMISSION HOLOGRAMS

Master transmission holograms can be used to make bright reflection and rainbow holograms. Most commercial reflection holograms on the market are made from transmission masters.

Split-beam reflection holograms

You are ready to work with split-beam holography. This is considered true holography. Split-beam holography offers important advantages over single-beam holography. One is the ability to control the light ratio of the reference beam to the object beam. For reflection holograms, this ratio is 2:1, reference to object, meaning that the reference beam should be twice as intense as the object beam.

Another advantage of split-beam work is being able to light the object more evenly and completely. In addition, you can move the model being holographed some distance away from the plate. This allows you to shoot larger objects.

BEAM PATH LENGTHS

When you are shooting split-beam holograms, the laser light illuminating the holographic plate is called the *reference beam*. The laser light illuminating the object is called the *object beam*. The length of the path of each beam to the holographic plate must be equal.

ADDITIONAL MATERIALS

To your growing supply of materials you need to add a few items: another radius mirror and one or two beam splitters. Since you are now working with split-beam holography, you must be concerned with the light ratios. To measure light ratios, you can purchase or build an inexpensive light meter. Appendix A describes how to build a simple light meter.

Light Meters

Whether you purchase or buy an inexpensive light meter, it will need to be calibrated. You can calibrate the meter as you work through different holographic setups. Once calibrated, the light meter will help you determine the proper beam ratios and exposure times.

Of course, there are also expensive laser light meters on the market that are pre-calibrated. The cost of these meters is usually out of range for beginning holographers. Also, I found I still needed to calibrate even these expensive meters to determine proper exposure times. In addition, I found that they did not always function in the feeble light of some split-beam assemblies.

You can also use standard photography light meters, but these too must be calibrated. The reason is that these photometers were designed to measure broad-spectrum light (natural or artificial). Laser light is monochromatic, single-frequency (632.8 nanometers), red light. This renders the readings from a standard light meter unreliable.

Measuring Light Intensities

In all setups, I recommend using a dummy glass plate during the measurement, not a real holograph plate. With the dummy glass plate positioned, block the beam not being measured (either the object or the reference beam). Place the sensor on the glass plate facing the illuminating beam. Criss-cross the sensor over the surface of the glass plate and take the average of the readings.

Beam Splitters

Beam splitters (BS), as their name suggests, split the laser beam into two separate beams; see Figure 6.1. Beam splitters are identified by their beam ratio. Typical ratios range from 1:1 to 9:1. I recommend that you purchase a 1:1 BS and a 9:1 splitter to start out with. There are also variable-ratio beam splitters, which can be tuned to any particular or fractional ratio need. Some variable-ratio beam splitters are constructed as a disk: rotating the disk varies the ratio of the laser beam passing through it. Other variable-ratio beam splitters look like a microscope slide. Moving the slide left to right varies the ratio of the laser beam passing through it. Variable-ratio beam splitters are expensive; you will probably work with fixed-ratio splitters.

For a 9:1 BS, you can substitute plane glass. The beam that travels through the glass is about nine times stronger than what is reflected from the surface. The disadvantage of using glass is that the surface of the glass does not have any optical coatings. This may cause a fine line pattern to form from the interference of the reflected laser light with the front and back surfaces of the glass. While noticeable, this does not seriously deteriorate the resulting hologram.

Beam Splitter

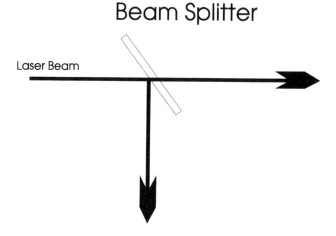

Figure 6.1. Operation of beam splitter.

TABLE SETUP

Materials needed:

One radius mirror with mounting
One plane glass plate 2.5 inches square with 2 clips and magnets
One 3 × 3-inch front-surface mirrors
One holographic plate
One model
One white alignment card
One shutter card

Optional Light Blocks

A *light block* can be made from black cardboard held with a medium-size binding clip. They are positioned around the table to prevent unwanted light from striking the holographic plate. They are identified on the drawings as "LB."

Setting Up

This holographic setup is simple. It uses a minimum of components. The disadvantage is that it is difficult to control the light ratio.

Figure 6.2 is a top view of your first split-beam setup. The radius mirror is positioned in front of the laser, directing the spread beam diagonally across the table.

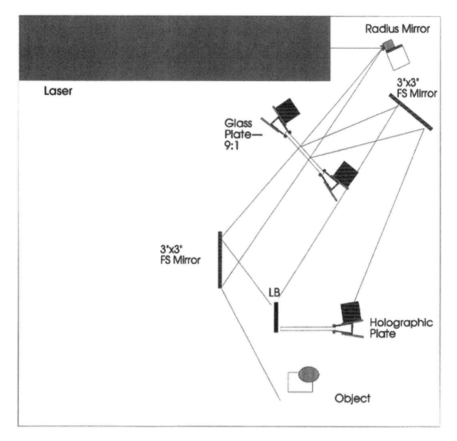

Figure 6.2 Top view.

Beam Splitters

The glass plate 9:1 BS is placed in the path of the spreading beam. For the 9:1 BS, I am using a discarded 2.5-inch holographic glass plate. (The emulsion on the holographic glass plate has been removed using a steel wool pad with soap and water.) The greater percentage of the laser light passes through the glass plate. This portion of the beam is used to illuminate the object.

Ideally, you are attempting to achieve a 2ref:1obj beam ratio when shooting a reflection hologram. The reason that the stronger portion of the beam is used to illuminate the object is that it is only the light reflected off the object that creates the interference patterns with the reference beam, creating the hologram. Naturally, the reflected light off the object has only a fraction of the light intensity of the original light illuminating the object.

More on Beam Splitters

There are two types of beam splitters: one transmits more light than it reflects, and the other reflects more light than it transmits (aside from the 1:1 beam splitter, which transmits and reflects the same amount of light). Both types of beam splitters work. But it is important to know what type of beam splitter you are working with. The holographic setups illustrated in this book, unless otherwise noted, assume a beam splitter that transmits a greater ratio of light.

First Mirror (Object Beam)

The two transfer mirrors used in this setup measure 3 × 3 inches. A small bar magnet is glued to the back of the mirror, flush with its edge. This allows the mirror to be quickly placed and held in position on the steel table. The light through the BS is reflected off of the first transfer mirror. The mirror is angled to illuminate the model with the laser light. The light illuminating the object is the object beam.

Positioning the Holographic Plate

The holographic plate is positioned approximately 1.5–2 inches in front of the model. Use a dummy glass (discarded and cleaned holographic plate) to accurately position the holographic plate. Lean a white alignment card, the same size as the holographic plate, on the holographic plate. The reflected light from the second transfer mirror should strike the plate between 30 and 45 degrees. The white alignment card makes it easier to see the spread laser beam. The laser beam should evenly illuminate the card. If it is hard to see the spread beam, turn off the room lights when making this adjustment.

The light from the first transfer mirror should only illuminate the model, not strike the holographic plate. You may need to position a light block between the mirror and the plate to accomplish this.

Measuring the Beam Path Distance

Using a tape measure (cloth), string, or wire, measure the total distance from the BS to the first transfer mirror, then from the mirror to the model and from the model to the holographic plate. Call this distance "Length A"; see Figure 6.3.

Positioning the Second Transfer Mirror

The length (or distance) the reference beam travels to the holographic plate must be equal to the "A" distance you have measured for the object beam.

If you have an assistant, have that person hold one end of the A-length string to the BS, and the other end of the string to the center of the holographic plate. With the string held at these two points, you can pull it

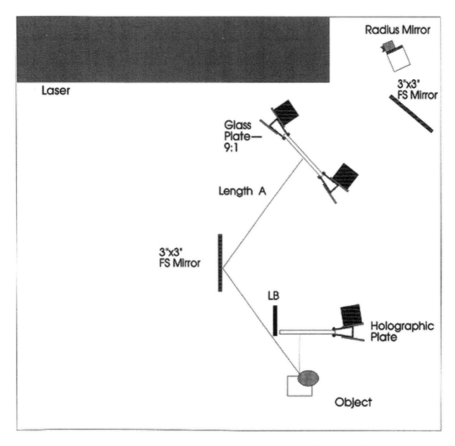

Figure 6.3. Measuring the total distance from the BS to the transfer mirror, from the transfer mirror to the model, and from the model to the holographic plate. The distance is identified as Length A.

out to position the mirror; see Figure 6.4. In Figure 6.4 the apex of the angle formed with the "A" length of string positions the mirror at precisely the correct distance. With the string pulled out around your finger you can move in an arc; see Figure 6.5. You can position the mirror anywhere along this arc and be at the proper distance to shoot a hologram.

The correct position to choose along the arc is one that will illuminate the holographic plate between 35 and 45 degrees.

CHECKING THE LIGHT RATIO

To check the light ratio, first block the object beam with the shutter card. Place the light meter sensor directly where the holographic plate will be positioned. If you have a blank piece of glass in this position (which I recommend), leave it there, and measure the reference beam light from behind

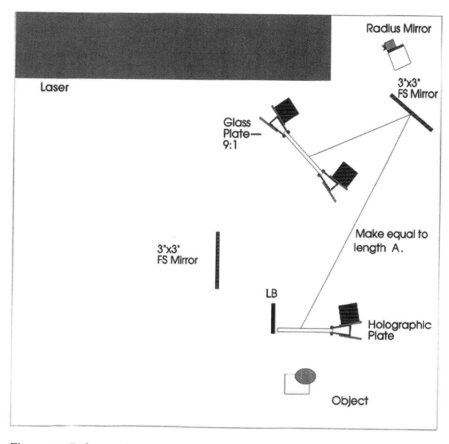

Figure 6.4. Reference beam path from BS to transfer mirror to holographic plate.

the glass. Criss-cross the surface of the dummy plate with the sensor and use the average reading. Make a note of the light intensity.

Next, unblock the object beam and block the reference beam with the shutter card. Position the light sensor behind the glass plate and measure the light reflected from the object. Make a note of the light intensity.

Ideally, the light intensity of the reference beam should be two times greater than the light intensity reflected from the object. If the light ratio is close to 2:1, shoot.

In this simple setup, controlling the light ratio is best accomplished by moving the object closer to or farther away from the plate. However, this will require that you remeasure all the distances and recheck.

EXPOSURE TIMES

To determine the best exposure time, make a series of test strips on a holographic plate. With the best exposure time determined, open up a log

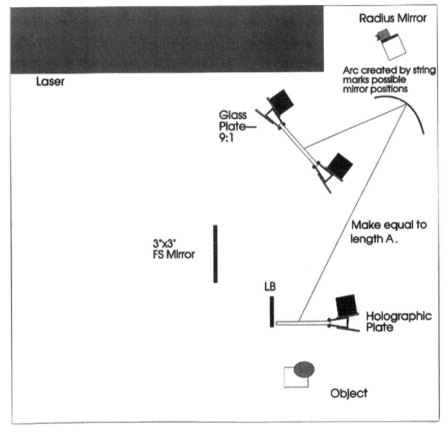

Figure 6.5. Using the "A" length of string to identify an arc of possible mirror positions.

and write down the reference and object beam intensities and the best exposure time.

Keep a journal of your holographic setups, beam intensities, and best exposure times and results (the quality of the finished hologram). The journal will become valuable as you continue shooting, because you will be able to look up a particular beam intensity and know what your exposure time should be. If you don't want to make a test plate, try these exposure times to get started.

EXPOSURE TIMES

Laser Power	Exposure Time
5-milliwatt laser	15 seconds
2.5-milliwatt laser	30 seconds
1.25-milliwatt laser	40 seconds

Development

Expose and develop the hologram as described previously for reflection-type holograms (80% dark by eye).

VIEWING THE FINISHED HOLOGRAM

The hologram must be completely dry before it is viewable. Use a point light source (tungsten halogen lamp, the sun, etc.) to view the virtual and real images. If the holographic image is not visible, or is fuzzy, faded, or shows other signs of trouble, check the "Trouble-Shooting Weak, Blurry, or Missing Holographic Images" section at the end of this chapter.

SECOND SPLIT-BEAM SETUP

In this setup you will use two radius mirrors. In general, the light intensity is varied by moving the radius mirror closer to or farther away from the object or holographic plate. To keep things interesting, you will also use an overhead reference beam.

Materials needed:

Two radius mirrors, one mounted on a 10-inch steel plate

One BS

One 3 × 3-inch front-surface mirror

One holographic plate

One model

One white alignment card

One shutter card

Figure 6.6 is a top-view illustration, which doesn't accurately show the upward angle of the laser beam from the BS. Figure 6.7 is a photograph of the setup, showing the beam paths. Figure 6.8 has all the table components labeled. To get an overhead reference beam, you will use the long 10 × 1 × 1/16-inch steel plate used in Chapter 4.

Beam Splitters

The laser is placed along the edge of the table. The first transfer mirror reflects the beam at a right angle. The BS is placed in the path of the reflected laser beam. Although the BS in Figure 6.8 is labeled 2:1, you may achieve the proper light ratio more easily using a 3:1 or 4:1 BS. The BS is tilted so that the reflected beam angles upward toward the overhead radius mirror.

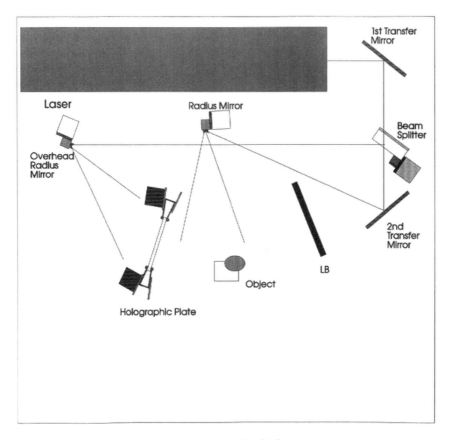

Figure 6.6. Top view of split-beam setup.

Overhead Radius Mirror

The overhead radius mirror is assembled using the long steel plate. One jumbo magnet is placed alongside the steel plate for stability. The radius mirror is attached to the upper portion of the steel plate.

Adjust the BS so that the beam strikes the overhead radius mirror. The radius mirror is adjusted so that the reflected spread beam strikes the table at a 45-degree angle. Use a protractor to check this angle.

Use a Dummy Plate

Place a dummy glass holographic plate on the table where the spread beam strikes. Place a white card behind the dummy glass to check that the beam completely covers the plate and that the spread beam is evenly distributed without any obvious imperfections.

If there are imperfections in the spread beam, try moving the radius mirror slightly so that the laser beam strikes a different portion of the radius mirror. Try to find an area where the beam is completely clean. If

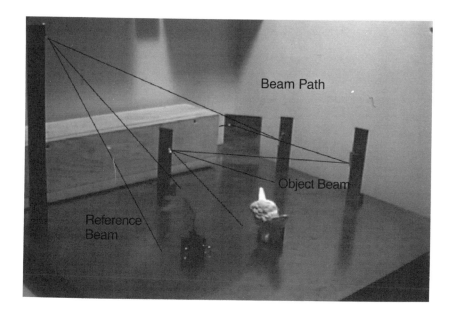

Figure 6.7. Photograph of table setup, showing beam paths.

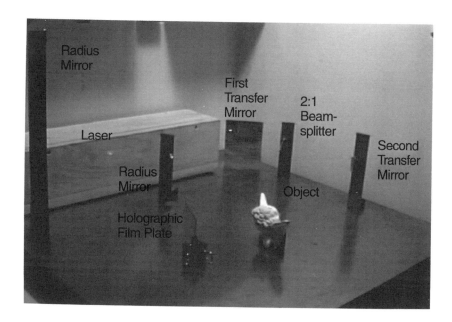

Figure 6.8. Photograph of table setup with table components labeled.

this is impossible, you may have to clean the optic. See "Cleaning the Radius Mirror" at the end of this chapter.

Positioning the Model

Place the model behind the dummy holographic plate. The model should be positioned so that none of the light from the reference beam directly illuminates it. If light is reflected from the table surface up toward the model, you may want to place a black card on the table in front of the model.

Second Transfer Mirror

The second transfer mirror reflects the beam traveling through the BS. The beam is directed toward the radius mirror that illuminates the object.

Measuring the Beam Paths

Measure the reference beam path, as illustrated in Figure 6.9. You will make the object beam path equal to this distance. The object beam path is illustrated in Figure 6.10. The easiest way to change the object beam path is to move the second transfer mirror toward or away from the BS.

Make the object beam path equal to the reference beam path by moving the second transfer mirror.

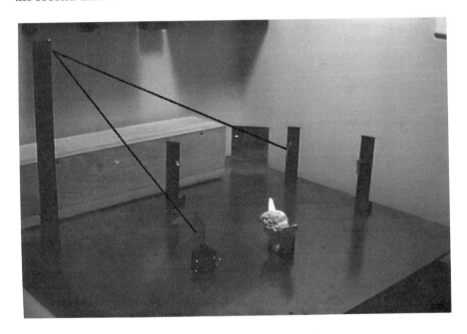

Figure 6.9. Reference beam path.

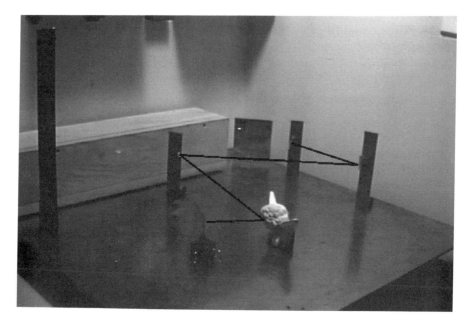

Figure 6.10. Object beam path.

Measuring the Light Ratio

Use the light meter to measure the relative intensities of each beam. First, block the object beam with the shutter card and measure the intensity of the reference beam at the holographic plate. Unblock the object beam and block the reference beam. Measure the light intensity of the light reflected from the object at the holographic plate.

The ideal light ratio is 2ref:1obj. To adjust the light intensity of either beam, move the radius mirror closer to or farther away from the model and/or plate.

REFERENCE BEAM TOO STRONG

If the light intensity from the reference beam at the holographic plate is much greater than the light intensity of the light reflected from the object, you need to adjust the ratio. You have a few options.

The best option is to switch the BS. The BS illustrated in Figure 6.8 is labeled 2:1. You may find that a 3:1, 4:1, or even a 9:1 BS provides a better light ratio. The reason that this is the best option is that you are using as much light as possible from the laser to make the exposure.

The second option is to place an ND filter in line with the reference beam, which will reduce the light intensity. This option is less desirable because you are wasting light.

The third option is to move the radius mirror farther away from the holographic plate. This is the least desirable option because it means remeasuring and realigning the entire setup.

LIGHT BLOCK

A light block can be made from various sizes of black cardboard secured to the table with clips or magnets. Its purpose is to block unwanted laser light from the holographic plate. A light block is illustrated in Figure 6.6. This light block prevents light from the BS from striking the holographic plate. Without a light block, when you are making the exposure, the holographic plate can see the stray light from the BS. Any stray light would only serve to degrade the resulting holographic image.

EXPOSURE TIMES

Mark down the light intensities in your log book. It is best to run a series of test exposures on a holographic plate to determine the best exposure time. If you don't want to make a test plate, try these exposure times to get started.

EXPOSURE TIMES

Laser Power	Exposure Time
5-milliwatt laser	20 seconds
2.5-milliwatt laser	30 seconds
1.25-milliwatt laser	40 seconds

DEVELOPMENT

Expose and develop the holographic plate for a reflection hologram as before.

VIEWING THE FINISHED HOLOGRAM

The hologram must be completely dry before it is viewable. Use a point light source (tungsten halogen lamp, the sun, etc.) to view the virtual and real images. If the holographic image is not visible, or is fuzzy, faded, or shows other signs of trouble, check the "Trouble-Shooting Weak, Blurry, or Missing Holographic Images" section at the end of this chapter.

INTRODUCING ANOTHER OBJECT BEAM

By adding two more components, a 1:1 BS and a radius mirror, you can introduce another object beam; see Figure 6.11. The two object beams provide superior lighting of the model.

The total length of the beam path of the second object beam must be equal to the length of the first object beam (which is equal to the length of the reference beam).

Begin by placing a 1:1 BS in the path of the first object beam. Direct the light to the second radius mirror, which is positioned to illuminate the model.

Compare the two object beam lengths from the 1:1 BS just put in the setup. Adjust the new object beam length to match the original object beam length. Don't touch the original object beam length, because it is already matched to the reference beam.

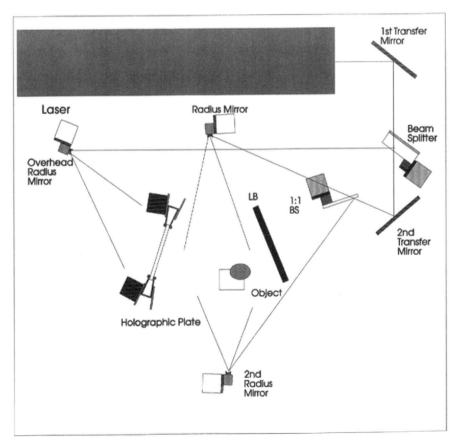

Figure 6.11. Adding two more components for improved lighting of the model.

CLEANING THE RADIUS MIRROR

A common cause of imperfections is dust on the mirror. Purchase a soft bristol artist's brush. Gently brush the surface of the radius mirror with the brush. This will remove most dust particles. Check the spread beam; if it has cleared up, you're finished—continue with the setup.

If brushing the dust off the mirror hasn't helped, you must clean the optic with a lens cleaner. Put a drop or two of lens cleaner on the surface of the radius mirror. With a lens tissue paper, using a circular motion, gently wipe the fluid away. This will clean the optic component. If the imperfection is still in the spread beam, it is a defect in the optic component itself.

CLEANING THE OPTICAL COMPONENTS

This same procedure can be used to clean all the optical components on the table: front-surface mirrors, radius mirrors, lens, beam splitters, and ND filters.

KEEPING COMPONENTS CLEAN

In general, you do not want to clean your optics with a liquid lens cleaner often. Each time you clean an optic, you may be removing a small portion of the optical coating or causing it to haze slightly. One trick many holographers use is to cover their optical components with a small sandwich bag when they are finished. The bag prevents dust from accumulating on the component.

TROUBLE-SHOOTING WEAK, BLURRY, OR
MISSING HOLOGRAPHIC IMAGES

This section is supplemental to the trouble-shooting guide at the end of Chapter 3. If you have eliminated the possible causes outlined in the first trouble-shooting guide, you need to look at the following:

Beam Path Lengths. If the beam paths aren't equal, the interference patterns you are trying to record will not be aligned. Recheck the beam path lengths.

Light Ratio. If the light ratios are too far from the ideal, you will not produce sharp images.

Component Drift. If you are using weak magnets, it is possible that they could drift off position when you are exposing the holographic plate. If the spread laser beam moves off its mark by itself, it is drifting. Use a stronger magnet to secure the component or shore it up with another magnet.

Split-beam transmission holograms

You are now ready to make split-beam transmission holograms. The light ratio for making transmission holograms is 4ref:1obj (reference to object) beam. Transmission holograms require a monochromatic light source to be viewed.

You may think that since transmission holograms require a monochromatic light source (typically a laser) to be viewed properly that these are less popular among holographers. Not so. Obviously, to sell holograms to the public, white light reflection is the only way to go. However, most commercial reflection holograms available for sale are made using a transmission master.

There are a few reasons for this. First, when making a reflection copy from a transmission master, you can place the holographic image on whatever plane you choose. For instance, you can place the image behind the holographic plate, have the image bisect the holographic plate, or have the image projected in front of the holographic plate.

If you aperture down the master when making a reflection copy, you reduce the vertical parallax of the copy hologram, but you increase the overall brightness of the image—so much so that the copy can be much brighter than an original reflection hologram made of the same scene.

In addition, the transmission master can also be used to produce a rainbow hologram. A rainbow hologram is unique, because it is a white-light-viewable transmission hologram. The rainbow hologram was developed by Steve Benton in 1969. At the time, Mr. Benton was working on a method to reduce the amount of information in a hologram for possible

television transmission. While 3D TV is still a while off, you can enjoy the byproduct of his research.

I will cover these techniques later.

FIRST SPLIT-BEAM TRANSMISSION HOLOGRAM

Materials needed:

One 2:1 BS

One transfer mirror

Two radius mirrors

One holographic plate

One ND filter

One white alignment card

One shutter card

An overview of the setup is illustrated in Figures 7.1 and 7.2. The BS used in this setup has a 2:1 ratio, meaning that it reflects twice as much light as it allows through.

The beam from the laser is reflected at a 90-degree angle by a transfer mirror. The 2:1 BS is placed in line with the reflected laser beam. The reflected beam from the BS is directed 90 degrees across the table to a radius mirror positioned near the end of the table.

Place another radius mirror near the end of the table, where the beam traveling through the BS is directed. Both radius mirrors are directed toward the center of the table; see Figure 7.3.

Place a dummy holographic plate near the center of the table. Direct the second radius mirror toward the dummy holographic plate. T align the beam, place a white card behind the glass plate and turn off any room lights. Position the dummy plate so that the light from the second radius mirror strikes the plate at a 30–45-degree angle.

The model is placed approximately 2 inches in front of the holographic plate, facing toward the BS. The first radius mirror is directed to illuminate the model. Before you begin measuring, look at the overall shape of the setup. Notice that each beam path forms half of a symmetric triangle, and uses the sides of the table to create straight beam paths. When creating different configurations, you can make measuring and adjusting the beam paths a bit easier by making the holographic setup symmetrical.

Measuring the Beam Paths

As with all split-beam holography, a good portion of your time is spent making each beam path length equal. Measure the beam paths as described before, using a tape measure, string, or wire. Adjust the beam paths until they are equal.

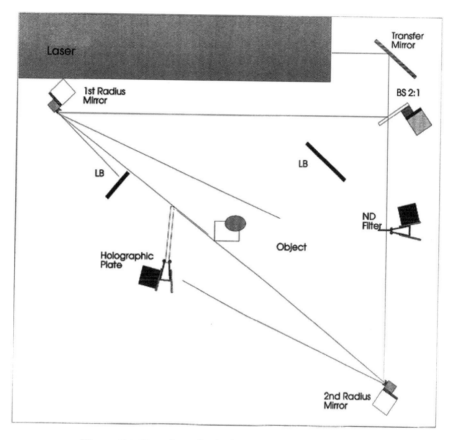

Figure 7.1. Drawing of split-beam transmission setup.

Measuring the Light Ratio

Using the light meter, measure the light intensity of each spread beam at the plane of the holographic plate. When making the measurement of the object beam, you are measuring the light reflected from the object at the holographic plate position. The ideal light ratio is 4:1 reference to object. When I made my light measurements, I found that the reference beam was far too bright.

Correcting the Reference Beam

As stated earlier, the reference beam should be approximately four times greater in light intensity than the reflected light hitting the holographic plate from the object. Even so, the reference beam was well beyond the ideal light ratio. To reduce the intensity, I placed an ND filter in line with the reference beam. The ND filter was held in a binding clip secured with

Figure 7.2. Photograph of split-beam setup.

a magnet to a steel plate that was secured to the isolation table with a magnet. The ND filter assembly is placed in between the BS and the object beam's radius mirror.

A better alternative (one that doesn't waste light) is to use a higher-ratio BS. Sometimes you may find yourself without the ideal component to use or to change a setup, so a workaround is called for. Rather than change the BS, I'll use a workaround, the ND filter.

Recheck the light ratio. It should be around 4:1. Write the measurements in your log book.

LIGHT BLOCKS

When the holographic setup is complete, look through the dummy plate to see how the finished hologram will appear. At this point you may notice a glow of light from the BS. If you can see this light, so will the holographic plate. (The light blocks shown in the schematics are removed from the pictures to reveal the table components.) To prevent this stray light from degrading your hologram, place a light block in front of the BS. In general, when re-creating the holographic setups, you should use light blocks to prevent stray laser light from striking the holographic plate.

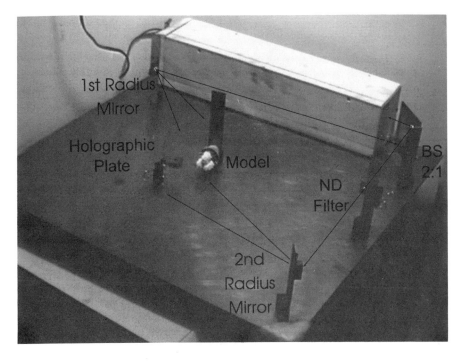

Figure 7.3. Labeled photograph of split-beam setup.

Positioning the Object Beam Light Block

Block the reference beam with a shutter card. All the light illuminating the table will be coming from the object beam. Position the beam with the radius mirror to light the model as evenly as possible. At this point, a portion of the object beam will probably be striking the holographic plate as well.

If the object beam light is allowed to strike the plate, it will degrade the resulting hologram.

Place a light block in the path of the object beam. Slide the light block into the beam until no light is striking the holographic plate. The model should still be evenly lit.

MAKING THE EXPOSURE

Place the shutter card in front of the laser. Remove the dummy holographic plate. Turn on your safelights and turn off any standard room illumination. Place a fresh holographic plate in position. Make a test exposure plate to find the best exposure. You can use the following times to get started.

EXPOSURE TIMES

Laser Power	Exposure Time
5-milliwatt laser	12 seconds
2.5-milliwatt laser	20 seconds
1.0-milliwatt laser	30 seconds

Development

Develop the hologram as before. The density transmission holograms should achieve is approximately 20% dark by eye.

Viewing the Finished Hologram

If you view a transmission hologram under white light, the image appears fuzzy and multicolored. To view the hologram, place it in the spread beam of the laser. The spread beam must illuminate the plate at the same angle at which the hologram was recorded. You may need to flip the holo-gram around to get it back to its proper orientation before you see the image. If you can see the outline of the clip that held the hologram, use that as a guide to correctly orient the hologram.

MAKING A MASTER TRANSMISSION HOLOGRAM

Master holograms are made for the general purpose of producing copy holograms. They should be of the highest quality the holographer can pro-duce. This means exacting beam ratios, distances, and exposure times. In most cases a spatial filter is used to produce a very clean reference beam (see Appendix B, "Spatial Filters"). While you will not be using a spatial filter, you still can produce good master holograms.
 Materials needed:

One 2:1 BS

One transfer mirror

Two radius mirrors

One holographic plate

One ND filter

One white alignment card

One shutter card

One large positive lens

 With a few minor modifications to the previous holographic setup you can produce a good transmission master. What separates a master

hologram from a standard hologram is that the angle at which the reference beam strikes the plate is changed to 30 degrees and the reference beam is collimated.

WHY A 30-DEGREE REFERENCE BEAM?

The angle of the reference beam is changed to 30 degrees. The reason for doing this is illustrated in Figure 7.4.

When you are making a copy hologram, it is important that the light illuminating the master hologram (H1) does not directly fall on the copy hologram (H2). A 30-degree reference angle on the master helps facilitate this.

COLLIMATED REFERENCE BEAM

The collimated reference beam prevents distortion in the projected real image.

HOLOGRAPHIC SETUP

You only need to make two minor modifications to your setup. If you leave the components in their places from the last setup, you do not have

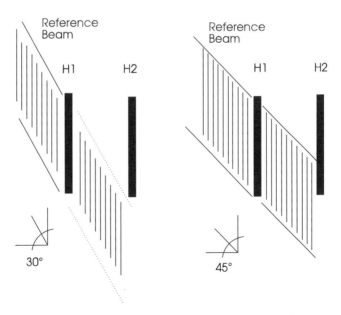

Figure 7.4. Thirty-degree reference beam not illuminating H2 plate.

to remeasure the beam paths; see Figures 7.5 and 7.6. First, pivot the plate so that the reference beam strikes it at a 30-degree angle. Next, place a large positive lens in the reference beam to collimate the beam.

The positive lens should be larger than the holographic plate (2.5 inches square) and have a short focal length. The short focal length facilitates its use on a small table. (You will find that most magnifying glasses have a short focal length.) The lens is placed at its focal-length distance from the radius mirror. For instance, if a lens has a focal length of 5 inches, it should be placed 5 inches away from the radius mirror.

To check the reference beam to make sure it is collimated, place a white card behind the collimating lens. The outline of the reference beam on the card should stay the same size when you move the card toward or away from the lens. If the outline doesn't stay the same size, move the lens a little and recheck. Continue to adjust the lens position until the beam is collimated.

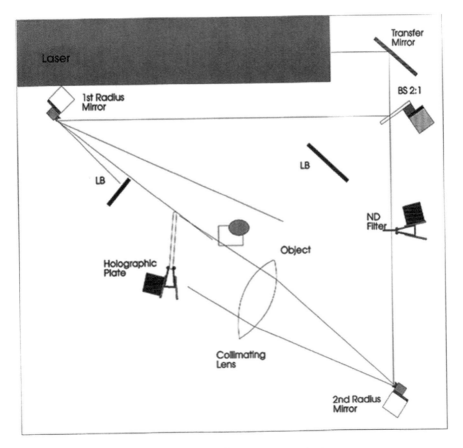

Figure 7.5. Illustration of master transmission setup.

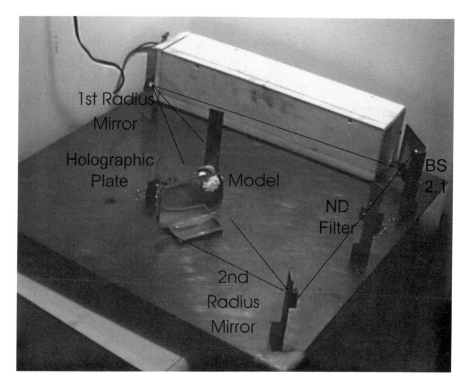

Figure 7.6. Photograph of master transmission setup.

Measuring the Light Ratios

The light ratios should be approximately the same as in the first setup. Measure them to make sure.

EXPOSURE TIMES

If you made a test exposure plate from the previous setup, use the best exposure time you've found. If not, use the following times to get started.

EXPOSURE TIMES

Laser Power	Exposure Time
5-milliwatt laser	12 seconds
2.5-milliwatt laser	20 seconds
1.0-milliwatt laser	30 seconds

Development

Develop the hologram as before. The density transmission holograms should achieve is approximately 20% dark by eye.

Viewing the Finished Hologram

View this hologram as you would any other transmission hologram. However, mark this hologram clearly as a master because you will be using it in Chapter 8 to make a reflection hologram and a rainbow hologram.

ADDING ANOTHER BEAM

Materials needed:

One 2:1 BS

One 1:1 BS

One transfer mirror

Three radius mirrors

One holographic plate

One ND filter

One white alignment card

One shutter card

One large positive lens

To produce better lighting for the model, you can introduce another object beam; see Figure 7.7. The 1:1 BS is placed in line with the object beam. The split beam is sent diagonally across the table to the third radius mirror. The third radius mirror is aligned to reflect light onto the model.

Measuring the Beam Paths

Since the first two beam paths have been measured and are equal, your task is to match this third beam to the first two. Begin measuring the second object beam from the first BS. Arrange the components so that this beam matches the first two in length.

Measuring the Light Ratios

The light ratio should be approximately the same as in the first setup. Measure the light ratios to make sure.

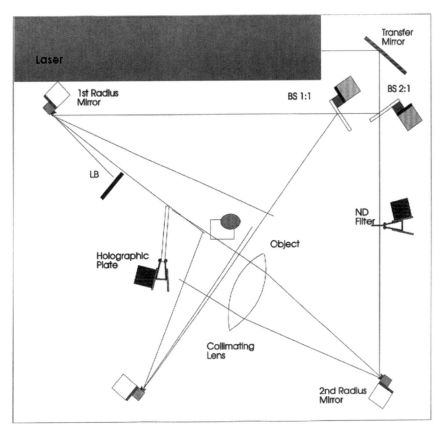

Figure 7.7. Introducing another object beam via 1:1 BS.

EXPOSURE TIMES

If you made a test exposure plate from the previous setup, use the best exposure time you've found. If not, use the following times to get started.

EXPOSURE TIMES

Laser Power	Exposure Time
5-milliwatt laser	12 seconds
2.5-milliwatt laser	20 seconds
1.0-milliwatt laser	30 seconds

Development

Develop the hologram as before. The density transmission holograms should achieve is approximately 20% dark by eye.

More holograms

In the previous chapters you have made good-quality transmission and reflection holograms. In this chapter you will advance in the art of holography. You will produce a bright reflection hologram from a transmission master, a rainbow hologram, a pseudocolor hologram, and a stereo hologram. You will end the chapter by shooting larger 4 × 5-inch holographic plates on your small isolation table.

REFLECTION FROM A TRANSMISSION MASTER

The next hologram outlined is a high-quality reflection hologram made from a transmission master. In many cases you can produce a brighter reflection hologram using this technique than shooting an original reflection hologram.

Figure 8.1 illustrates the basic process. You illuminate the master transmission hologram, H1, so that it projects its real image. The real image projects onto your copy hologram, H2, which has its reference beam striking it from the opposite side. Notice that the beam illuminating H1 does not strike the copy plate H2.

You can improve the brightness of the resulting copy hologram by using a reduced aperture; see Figure 8.2. This process limits the vertical parallax of the resulting hologram somewhat but improves the overall brightness of the holographic image. The reason is that there is a greater percentage of recording material (film) reconstructing a smaller portion of the original hologram.

It is not necessary to place the slit aperture onto or next to the master hologram, but that does illustrate the point best. For instance, the aperture I used was made from two pieces of black cardboard positioned in front of the collimating lens, creating a slit aperture. You will produce a reflection hologram from a transmission master using a reduced aperture.

Figure 8.1. Open-aperture transmission to reflection hologram.

Most commercial reflection holograms are produced using this method. In addition to producing a bright reflection hologram, it is possible to move the holographic image in front of, bisecting, or behind the holographic plate.

Materials needed:

One master transmission hologram

One H2 plate

Two radius mirrors and magnetic assemblies

One collimating lens

One ND filter

One 3:1 BS

One transfer mirror

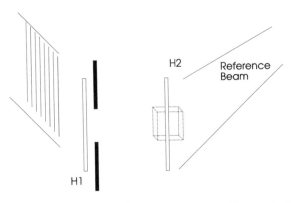

Figure 8.2. Aperture-restricted transmission to reflection hologram.

SETUP

Figure 8.3 illustrates your table setup. The beam from the laser is reflected by the transfer mirror 90 degrees along the edge of the table; see Figure 8.4. A radius mirror is positioned at the corner of the table to intercept the beam and reflect the spread beam toward the center of the table; see Figure 8.3. The lens is positioned in the spread beam path to produce a collimated beam; see Figure 8.5.

The master transmission hologram (H1) is positioned in the collimated beam (see Figure 8.6). The angle at which the collimated beam should strike the master is approximately 30 degrees. Orient the hologram so that when you look through the plate from the opposite side of the illuminating beam, you see the virtual image. Twist the hologram left and right slightly to vary the 30-degree spread beam's intercept angle. Leave it in the position that produces the brightest image.

Flip the hologram around (180 degrees). When you look through the plate, you will see the real image. Don't worry if the image appears distorted. Again, vary the angle at which the spread beam strikes the plate by twisting the plate left and right. Leave it in the position that produces the brightest image. Lock H1 into place, using a magnet on each clip.

Place a white card or ground glass about 2 inches in front of H1; see Figure 8.7. Ground glass may be used as a projection screen. In some cases it is essential when it is necessary to view an image (or holograph) from the opposite side of projection. Keep the white card or ground glass parallel to H1. The white card (or ground glass) should be far enough away so that the object beam does not strike it directly.

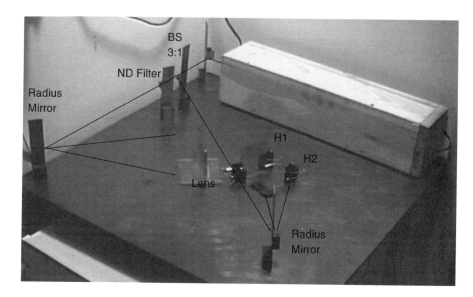

Figure 8.4. Transfer mirror placement.

Ground glass or a piece of clear glass with tracing paper taped to it is preferable to a white card, the reason being that you can look through the ground glass (or tracing paper) to optimize alignment, while with the white card you must always look from the opposite side. Next, flip the hologram over 180 degrees. When you look through the plate now, the real image should be clearly projected onto the screen. If you cannot see it clearly, turn off any standard room illumination.

APERTURE RESTRICTION

In order to produce a bright reflection hologram, you are going to use aperture restriction. Use two light blocks, as shown in Figure 8.8. Move the light blocks into the beam until approximately 50% of H1 is illuminated.

At this point, you can move the screen position a little closer to H1, but do not let any light from the object beam strike the screen directly.

The next step is to place the 3:1 BS in the path of the laser beam; see Figure 8.9. Then measure the path of the object beam. Using a wire, string,

Figure 8.5. Radius mirror placement.

or tape measure, start from the BS, continue to the radius mirror, then to H1, and finally to H2.

Have an assistant hold one end of the wire to the BS and the other end to the center of H2. Form an apex in the wire, using your finger or a pencil. You can form an arc of possible radius mirror positions; see Figure 8.10. Choose a position that provides a good reference beam angle to H2; see Figure 8.11.

Figure 8.12 is a top view of the finished setup.

MEASURING THE LIGHT RATIOS

The ideal light ratio for this setup is 3:2, reference to object beam. Place a dummy glass in the H2 position. Shutter the object beam when measuring the reference beam, and vice versa. When you measure the object beam, the light intensity will vary greatly on the plane of H2, from bright parts of the image to darker portions. Use the highest light reading from the object beam in making calculations.

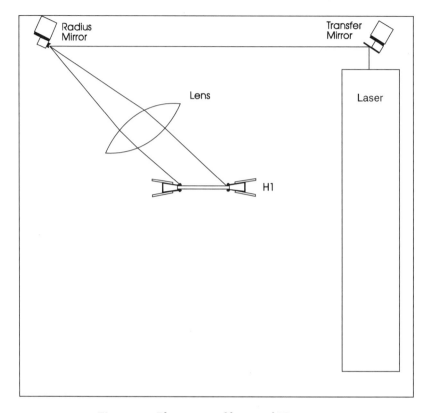

Figure 8.6. Placement of lens and H1 master.

When I measured the light ratios in my setup I found the object beam to be too strong. To correct this problem I placed an ND filter in line with the object beam.

EXPOSURE TIMES

Mark down the light intensities in your log book. It is best to run a series of test exposures on a holographic plate to determine the best exposure time. If you don't want to make a test plate, try these exposure times to get started.

EXPOSURE TIMES

Laser Power	Exposure Time
5-milliwatt laser	20 seconds
2.5-milliwatt laser	30 seconds
1.25-milliwatt laser	40 seconds

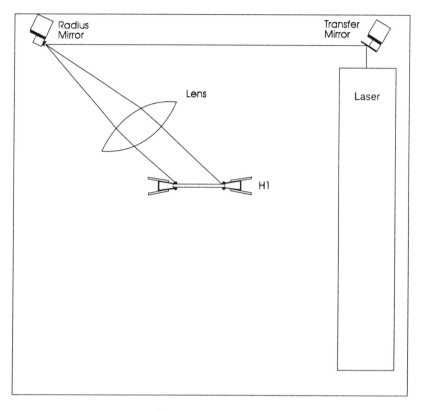

Figure 8.7. Placement of ground glass screen.

Development

Expose and develop the holographic plate for a reflection hologram as before (80–90% dark by eye).

Viewing the Finished Hologram

The hologram must be completely dry before it is viewable. Use a point light source (tungsten halogen lamp, the sun, etc.) to view the virtual and real images.

RAINBOW HOLOGRAMS

Rainbow holograms are unique because they are white-light-viewable transmission holograms. These holograms were first created by Steven Benton in 1969. At the time, Benton was working at Polaroid Corporation. He was looking for a way to reduce the holographic infor-

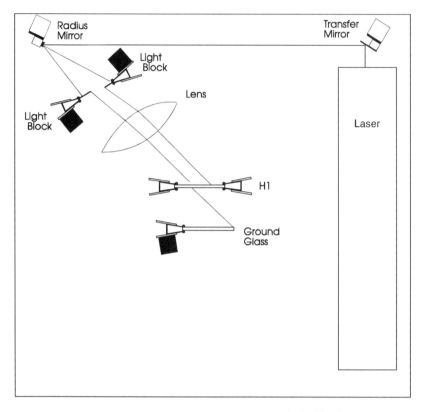

Figure 8.8. Creating an aperture using 2 light blocks.

mation contained in a hologram, while still retaining the 3D image, for possible television transmission.

Before I discuss his discovery, let's first review what happens when you view a transmission hologram using white light; see Figure 8.13. When you view a transmission hologram with white light, you see a fuzzy multicolor image. The transmission hologram is acting like a diffraction grating: each component color of the white light is reconstructing the holographic image. Because each color has a slightly different focal point, each holographic image reconstructs at a slightly different focal point. The end result is that all the images combine to form one fuzzy multicolor image.

Benton sought to reduce the holographic information by placing a slit aperture on the hologram; see Figure 8.14. The aperture sacrificed most of its vertical parallax, but left the horizontal parallax intact in the copy hologram. Since most people observe 3D images by moving their heads left to right, the impact of losing the vertical parallax is acceptable.

The copy hologram produced in Figure 8.14 may be called a *rainbow hologram* or a *white light transmission hologram*. When you view

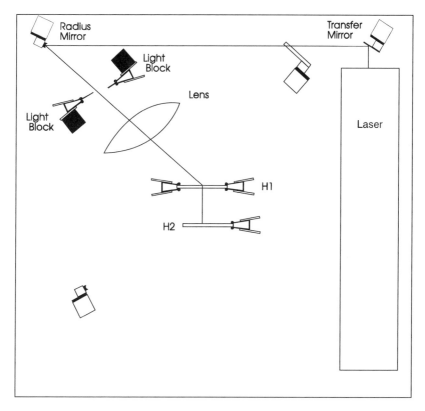

Figure 8.9. Placing the BS and measuring the length of the object beam.

a rainbow hologram with white light, the image remains sharp; see Figure 8.15.

If you move your head (or the hologram) vertically, the image remains the same but shifts through the colors of the rainbow; hence the name rainbow hologram. Because this type of transmission hologram is viewable under white light, it is also called a white light transmission hologram.

Materials needed:

One H1 master transmission hologram

One H2 copy plate

One 9:1 BS

Four front-surface mirrors

Two radius mirrors

One collimating lens

Two black cards to create aperture

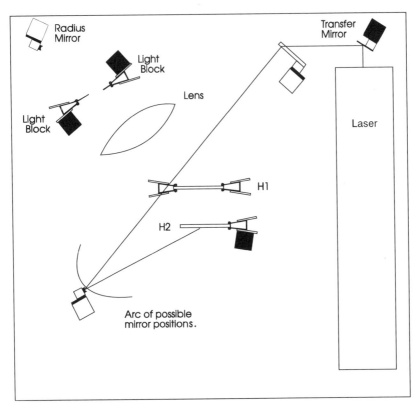

Figure 8.10. Forming an apex of possible mirror positions.

SETUP

The setup is shown in Figure 8.16 and the top-view illustration is shown in Figure 8.17. When I matched the beam paths on this particular setup, the object beam was far too long to make an equalizing adjustment. I had to incorporate what is known as a *light fold*. The light fold used in this setup is circled in Figure 8.18. The light fold is constructed of two front-surface mirrors, and its only purpose is to increase the length of the beam path. Light folds can be used whenever it becomes too difficult to equalize the two beam paths by other methods.

The light ratio used in this setup is the same as with standard transmission holography, 4:1.

When you are producing your first rainbow hologram, I recommend not reducing the slit aperture to less than 1/3 of the H1 masterplate. The reason you are keeping the aperture slit wide is that your transmission hologram was not made specifically to produce a rainbow hologram. Typically, rainbow masters have their subjects farther away (8–12 inches) from the holographic plate when being shot.

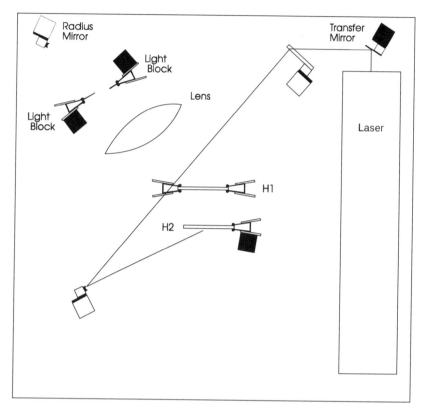

Figure 8.11. Reference beam radius mirror position.

PSEUDOCOLOR HOLOGRAMS

Master transmission holograms can also be used to produce achromatic (black and white) and full-color copy holograms. The techniques used are beyond the scope of this book. For those of you who wish to pursue this line of experimentation, I recommend the following two papers to get you started:

Benton, S.A. "Achromatic Images from White Light Transmission Holograms." *J. Opt. Soc. AM* 88 (October 1978): 1441A.

Tamura, P.N. "Multicolor Image from Superposition of Rainbow Holograms." *SPIE* 12 (1977): 59–66.

Making Pseudocolor Holograms

Full-color and true-color holography is out of reach for novice holographers. However, there is a relatively easy technique you can apply to shift the color of reflection holograms.

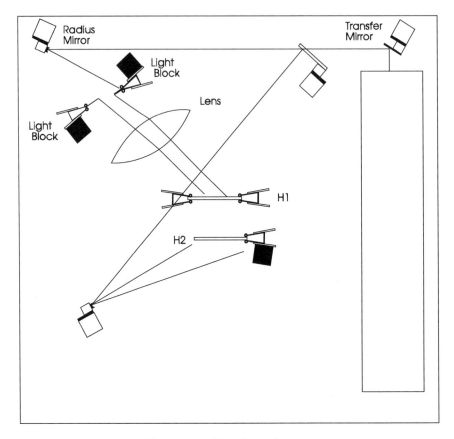

Figure 8.12. Top view of setup.

Triethanolamine

Triethanolamine (TEA) is a clear fluid that dissolves in water. When holographic plates are treated with this compound, the emulsion swells. Afterwards, the plate is exposed and goes through the normal developing process. During the development processing, the TEA compound is washed away and the emulsion shrinks back to its normal size.

How the color shifts is interesting. Since the interference pattern is recorded at 632.8 NM (red laser light) in the swelled emulsion, when the TEA washes out during development, the interference pattern also shrinks (or compresses), along with the emulsion. This shrinking causes the reconstructed image to play back at a higher (shorter) frequency color. Different percentages of TEA compounds mixed with distilled water produce different colors. For instance:

0%-Red

10%-Yellow

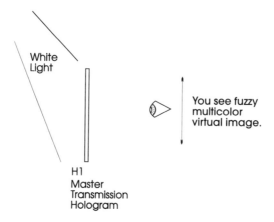

Figure 8.13. Viewing a transmission hologram in white light.

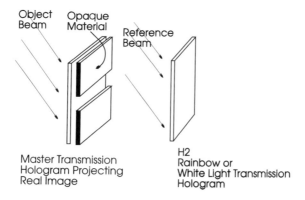

Figure 8.14. Creating a rainbow hologram from a transmission master.

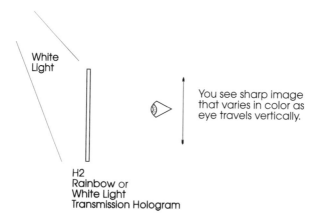

Figure 8.15. Viewing a white light transmission hologram.

Figure 8.16. Photograph of rainbow table setup.

14%-Green

20%-Blue

To make a batch of TEA solution, add the percentage required (in milli-liters) in enough distilled water to make 100 milliliters. For example, to produce a 10% solution of TEA, measure out 10 milliliters of TEA, then add 90 milliliters of distilled water to make 100 milliliters of solution.

Treating Plates

Under a safelight, pour the TEA solution into a tray. Place an unexposed plate into the tray, emulsion side up. Make sure the TEA solution com-pletely covers the plate. Keep the plate in the TEA solution for 1 minute. Then remove the plate, squeegee the excess solution from it, and allow it to dry completely (about 20–30 minutes).

The plate is now ready for exposure.

Exposure Times

TEA-treated film becomes faster, requiring less exposure time. Typically you can reduce the exposure time by 1/3 to 1/2, compared to unexposed plates. Expose and develop the plate normally.

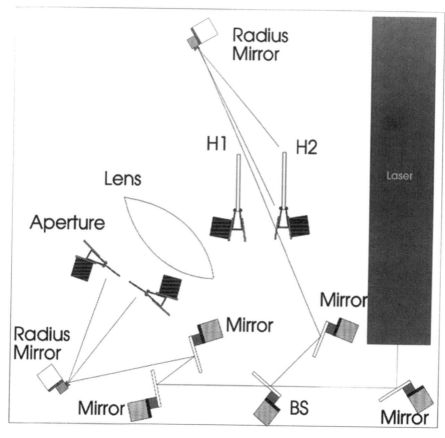

Figure 8.17. Top-view illustration of rainbow table setup.

TEA Deteroriation

You cannot store TEA-treated plates for more than a few hours because they will begin to deteriorate. Only treat plates that you will be using within a few hours.

STEREOGRAMS

Stereograms are holograms created using a series of 2D pictures (slides or film). Substantial improvements in this technology have been produced by D.J. DeBitettro, Lloyd Cross, and Steve Benton. The advantages of producing stereograms are many. For instance, you can produce a holographic portrait of a person without using an extremely expensive pulse laser (ruby or YAG) system. You can create holograms of objects too large for studio setups, like cars, buildings, mountains, even the world (although be warned: if you plan to produce a hologram of

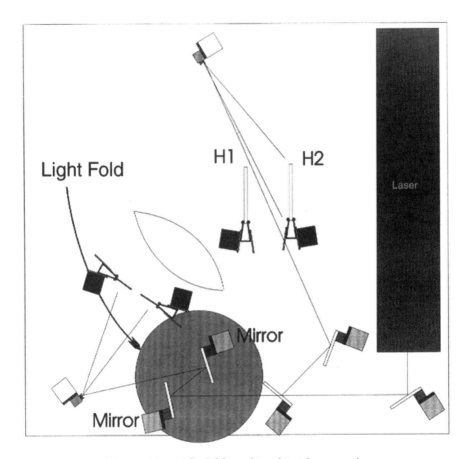

Figure 8.18. Light fold used in object beam path.

the world, it's already been done, using a sequence of weather satellite pictures).

You will use a basic setup to produce a hologram from a series of slides taken with a 35-mm camera.

Taking the Pictures

The setup for taking the pictures is illustrated in Figure 8.19. Load the 35-mm camera with color slide film (24 exposures). A table or bench is positioned in front of the model. The distance between the table and the model is determined by the model's size or the view of the model you want to capture. For instance, if you are shooting just the model's head, you would be positioned much closer than when shooting the full body. As a general guideline, the image you want to capture should fill the view finder of the camera.

Film Type = Slide

Start.
Shoot 1 frame every 4".
Keep camera pointing straight ahead–
do not aim toward model.

Figure 8.19. Setup for taking pictures for a stereohologram.

As with the distance between the model and the table, the distance you should move the camera between shots is also determined by the model. Use Figure 8.20 as a guide. Find the horizontal span by first positioning the camera so the view of the model looks like frame 1 in Figure 8.20. Then position the camera so the view of the model looks like frame 24. Divide this distance by 24; let's call this number the *increment* (distance/24 = increment). This is the distance you will move the camera horizontally between shots. Mark the total distance you need to travel on the table. Then mark each increment with a line. These lines will be a guide when shooting the frames.

When you are shooting the frames, the camera must be pointed straight ahead. If you aim the camera toward the model, the entire effect will be lost. The model should hold the same pose for all 24 exposures. Have the film developed.

View Finder

Start Frame 1 Frame 12 Frame 24

Keep camera pointed straight ahead.
As camera pans, model's image in viewfinder
changes as illustrated above.

Model holds same pose for 24 exposures.
Use same lighting (off camera) for all exposures.

Figure 8.20. View through the camera view finder when shooting a sequence of slide pictures.

FIXTURES

You will need to make two slide fixtures and ten slit apertures. Let's start with the slide fixture.

Slide Fixtures

The *slide fixture* holds the slide in the holographic setup. The reason that you need a fixture to do this is that you will be changing the slide ten times, and it is important that each slide be accurately registered with the others. Figure 8.21 illustrates the slide fixture.

Materials needed:

One steel plate, 1 × 5 × 1/16 inch thick

One square magnet

One medium-size holding clip

Three scraps of material (see text)

Hot-glue

The 1 × 5 × 1/16-inch thick steel plate is used as a base. The magnet is positioned on one end of the base. Although the magnet will secure itself to the base, it is also hot-glued into position so that it doesn't move. Next, the medium-sized binding clip is secured to the magnet. The binding clip is hot-glued to the magnet. Only apply glue to the top spine of the binding clip, where it comes into contact with the magnet. This secures the binding clip while allowing you to open it easily to put in slides.

Next, position a slide in the binding clip. You need three scraps of material 1/16 inch thick, 1/4 inch wide, by about 1 inch long. I used

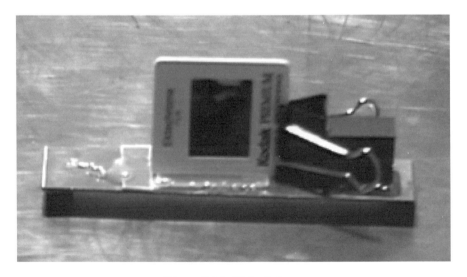

Figure 8.21. Slide fixture.

scraps of some copper-clad board I had lying around. Any rigid material can be used, for example, pieces of a popsicle stick. Hot-glue one piece of scrap material in front of and one behind the slide. These first two pieces will form a channel that will register the slide horizontally. Butt the third piece of material against the edge of the slide and hot-glue it into position. When you place a slide in the fixture, make sure it is positioned so that its edge touches the third piece of scrap material. This will register the slide vertically on the fixture. The binding clip secures the position.

Holographic Plate Fixtures

The holographic plate fixture holds the holographic plate plus the slit apertures.

Materials needed:

One steel plate, $1 \times 5 \times 1/16$ inch thick

One square magnet

One medium-size holding clip

Six scraps of material (see text)

Hot-glue

The holographic plate fixture is illustrated in Figure 8.22. This fixture is made the same way the slide fixture is made, using a dummy glass holo-

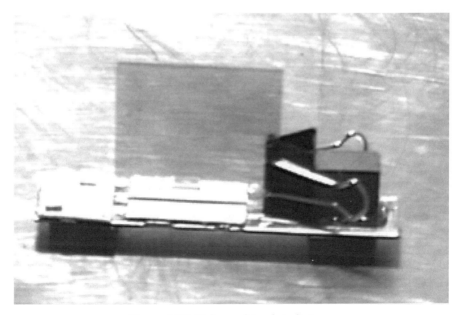

Figure 8.22. Holographic plate fixture.

graphic plate instead of the slide. You will be left with three scraps of material. These can be positioned after you make the slit apertures.

Slit Apertures

The slit apertures are made from ten pieces of 3.5 × 3.5 × 1/4-inch- (or 1/8-inch) thick transparent plastic. Figure 8.23 shows the first three slit apertures.

Materials needed:

Ten pieces of 3.5 × 3.5 × 1/4-inch transparent plastic

One roll of 1/4-inch masking tape

Black sign paint (for plastic and glass)

You begin by taping the plastic squares. Get one plastic square, place a strip of 1/4-inch tape across the entire width and along the bottom of one side. Get the next piece of plastic and place a strip of 1/4-inch tape across the entire width, 1/4 inch up from the bottom. Continue in this manner, moving the tape 1/4 inch up in sequence, until you have taped the 10 plastic pieces.

After the pieces are taped, you are ready to paint. The paint that is needed is specially designed for painting on plastic or glass. It is Sign Painters 1 Shot, lettering enamel paint 199-L Black. The paint is available through Images Company. Do not substitute a different paint, because chances are it will not work. Paint the surface of each plastic piece that has the 1/4-inch tape. Before the paint dries, remove the 1/4-inch tape. Removing the tape while the paint is still tacky will prevent cracking and peeling paint.

After the paint has completely dried, you can use one plastic piece to finish the holographic plate fixture.

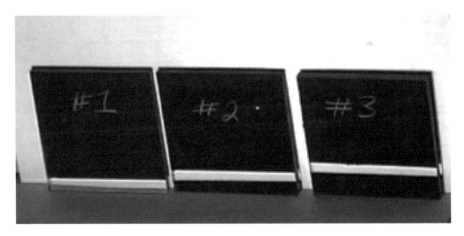

Figure 8.23. Slit apertures.

Holographic Plate Fixtures (continued)

Place one of the slit apertures next to the holographic plate. Secure the position by gluing two scraps of material, one along the front, and the other at the edge; see Figure 8.24.

STEREOGRAPHIC SETUP

The stereographic setup is illustrated in Figure 8.24. You are producing a transmission hologram. The light ratio is 4:1 reference to object.
Materials needed:

One 9:1 BS

Two transfer mirrors (one must be 3 × 3 inches)

One white screen

One slide fixture

One holographic plate fixture

One collimating lens

Two radius mirrors

Ten slides

Ten slit aperture plates

Figure 8.24. Holographic plate fixture with slit aperture.

The white screen used in this setup is a piece of heavy white cardboard with a magnet glued to the back. If you can't find heavy white cardboard, glue or tape white paper to a sheet of plastic. On the opposite side of the plastic, tape or glue black paper. The white card serves two purposes: first, as a screen for the slide image (obvious) and second, as a light block that prevents the reference beam from interfering with the image. For instance, if you are using a semi-transparent material, like ground glass, for a screen, any reference beam light hitting from the opposite side will wash out the image and create destructive interference.

Set up the table as illustrated in Figure 8.25. The light from the second radius mirror passes through the slide on the slide fixture. The image is bounced off the 3 × 3-inch front-surface transfer mirror onto the screen. The angles of the slide, mirror, and screen should all be approximately the same to keep the image distortion to a minimum.

Secure the positions of the holographic plate holder and slide holder using magnets butted on the sides of the base plate—or you can do

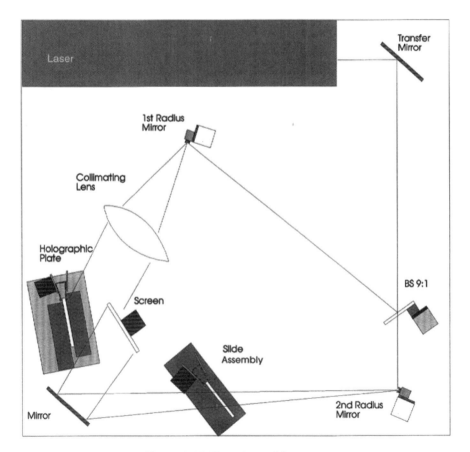

Figure 8.25. Top view table setup.

as I have done and place magnets underneath the base plates to raise the assemblies off the table a little.

Measure each beam path and make them equal. Measure the light ratio and make it 4:1, reference to object.

Making the Exposures

To create the stereogram, you will be making 10 exposures on a single holographic plate. The first step is to choose the slides you will be using. You shot 24 frames of slide film. Starting with the first slide, pick out every other slide. If the slides are in numerical order, you would choose slides 1, 3, 5, 7, 9, 11, 13, 15, 17, 19, 21, and 23. Eliminate the first and last slides (1 and 23) in this sequence. This leaves the 10 slides you will use.

Turn off all room illumination, and turn on your safelights. Load a fresh holographic plate into the plate fixture.

Place the first slide in the slide holder. Because you are using side lighting for the reference beam, the subject in the slide should be positioned on its side.

Position the first slit aperture in front of the holographic plate. Paint the side of the slit aperture facing toward the holographic plate; see Figure 8.24. Lift the shutter card, using the technique described in previous chapters, and make the exposure. Once the exposure has been made, place the next slide in the slide holder and replace slit aperture #1 with slit aperture #2. Make the exposure as before. Continue in this manner until you have shot the 10 slides; see Figure 8.26.

Once the sequence has been shot, develop the plate as a transmission hologram.

The sequence of pictures exposed on the plate forms a series of strip holograms. When observed under laser illumination, the pictures form a hologram. Higher resolution can be obtained by using a smaller slit aperture and a greater number of pictures. The transmission hologram can be converted into a bright reflection hologram, as described in the "Reflection from Transmission Master" section at the beginning of this chapter.

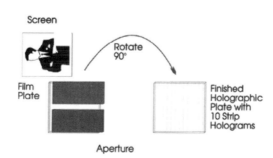

Figure 8.26. Slit holograms produced on a single holographic plate.

Exposure Times

Because you are investing a lot of time and energy in this hologram, I advise you to make a few test exposures to determine the best exposure time. Place a slide in the slide fixture and load a fresh holographic plate into the holder. Use four different slit apertures to make four exposures on the holographic plate, varying the time of each exposure. There's no reason to change slides for making the exposure test, so keep the same slide in the fixture. You can use the following times to get started.

EXPOSURE TIMES

Laser Power	*Exposure Time*
5-milliwatt laser	12 seconds
2.5-milliwatt laser	20 seconds
1.0-milliwatt laser	30 seconds

Develop the plate (for transmission) and see which time yielded the best results. Use that exposure time to create the stereogram.

More Information

You can learn more about shooting stereographic holograms by reading the following papers:

DeBitettro, D.J. "Holographic Panoramic Stereograms Synthesized from White Light Recordings." *Applied Optics* 8 (1969): 1740–1741.

Molteni, W.J. Jr. "Black and White Stereograms." Proceedings of International Symposium on Display Holography (1982).

LARGE FORMAT

Throughout this book you have used 2.5 × 2.5-inch glass holographic plates. Larger holograms in general are more dramatic and impressive. It is very easy to shoot 4 × 5-inch glass plates on your table.
 Materials needed:

One 4 × 5-inch holographic plate

One radius mirror

One small positive lens (13-mm diameter × 9-mm focal length)

With the addition of a small positive lens, spreading the laser beam before it strikes the radius mirror, you can easily spread the laser beam to cover large (4 × 5-inch) holographic plates. Figure 8.27 shows a typical single-beam reflection setup. In this setup the radius mirror spreads the beam to

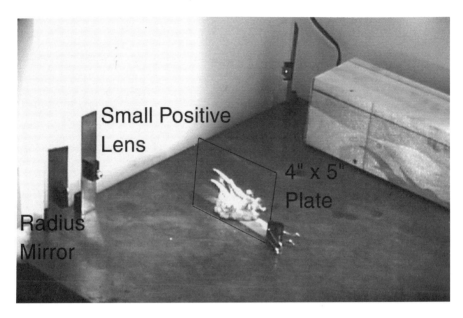

Figure 8.27. Shooting large format film with 4" × 5" holographic plate on table.

cover the 4 × 5-inch plate in 8 inches. The procedure for shooting the larger format is the same as for the smaller format.

Exposure Times

Since the spread beam is covering approximately four times the area that the 2.5-inch plates did, you can estimate the exposure time to be three to four times longer.

When using the larger format, you may want to secure both ends with a binding clip to ensure rock-solid stability. To gain experience with the larger format, you may want to backtrack in the book and try shooting some of the single-beam setups.

Using the radius mirror with lens assist, you can shoot single- and simple split-beam holograms. Do not be surprised if some people question your shooting 5-inch split-beam holograms on a tiny 24-inch square table.

Light meter

A light meter is useful in determining the proper exposure for optimizing the resulting holographic image. Overexposed and underexposed holograms offer weak images. For split-beam work, the light meter is useful for determining the light ratios of the reference and object beams.

Figure A.1 is a schematic of a suitable laser light meter. The sensor is a standard CdS photocell. The photocell changes in resistance in proportion to the amount of light that illuminates it. The change in resistance is read as a voltage on the 0–15 voltmeter.

Power is supplied by two miniature 12-volt batteries in series to supply a total of 24 volts to the circuit. A 15-volt zener diode regulates the voltage to 15 volts. Use approximately 5 feet of wire to connect the light sensor to the circuit. When taking readings on the isolation table it will be much easier to position just the sensor rather than the entire light meter assembly. A green subminiature LED is glued or secured to the voltmeter case. This provides illumination for reading the meter in a darkened room. The green color of the LED will have the least amount of impact on holographic materials you may have around. The 22-k ohm resistor in series with the voltmeter is included with a 0–15 voltmeter from Radio-Shack™.

CALIBRATING THE METER

To use the meter for holography, you need to calibrate it. The procedure is to take a laser light reading using the meter, then make exposure test strips on a holographic plate. Then calibrate the best exposure time to the meter reading for future exposures.

Set up the holography table to shoot a reflection hologram. Turn off all lights except the laser. Position the light sensor in the plane where the holographic plate will be, so that it "sees" the amount of light that will be falling on the holographic plate. Record the meter reading.

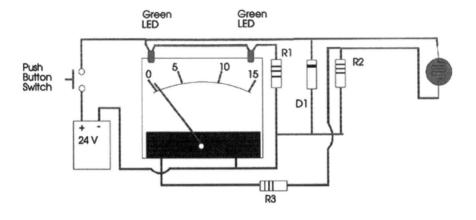

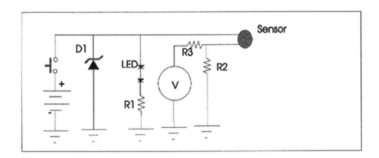

Figure A.1. Schematic light meter.

Put a fresh holographic plate in position. Position the exposure fixture described at the end of Chapter 3 on the holographic plate. Position the fixture so that 1/4 of the plate (film) will be exposed when the shutter card is removed. Make one exposure. Reshutter the laser and move the fixture so that an additional 1/4 of the plate is exposed. Allow enough time for the table to settle between exposures. Make a second exposure. Continue in this manner, making a total of four timed exposures on this plate; see Figure A.1.

Develop the plate and judge which exposure produced the best image. Reshoot another plate, and time the exposures to be a little below and a little above the best exposure time found from the first plate. Develop and determine which exposure time produced the best image. Mark this exposure time in seconds in your log book.

The next time you take a light reading that reads this voltage for a similar reflection hologram, you will be able to determine the proper exposure. To make the meter more useful, you should take notes and make exposure test strips for a variety of holographic setups and lighting

situations. This will make your light meter one of your most valuable holographic instruments. Here are a few helpful hints to get you started.

1. Glass holographic plates are typically 50% slower than acetate holographic film.
2. Film that is sandwiched between two pieces of transparent glass or plastic (simple film holder) is 50% slower than glass plates, due to the loss of light from the reflection of light from the plate's surfaces.
3. Exact exposure time of holographic emulsions varies from batch to batch.

You may think that the preceding information makes it difficult to determine exposure, even with a meter. Not so; as you gain experience the meter will be a useful tool that you will rely upon.

LIGHT METERS

DC VOLTMETER

Radio-Shack	270-1754
SPST momentary N.O.	275-1571
1N4744 15-volt zener diode	276-564
Green LED	276-022
4.7-k ohm resistor	271-1330
10-k ohm resistor	271-1335
12-volt battery	23-144
CdS photocells	276-1660

Spatial filter

A spatial filter cleans the laser beam of any imperfections. The operation of a spatial filter is easy to understand; Figure B.1 illustrates.

The main components of a spatial filter are a lens and a pinhole. The laser beam is directed into the lens. Only light that is perfectly focused on the pinhole can pass through. All other light, which contains the imperfections, is effectively blocked. The light passing through a spatial filter is very clean and makes excellent holograms. In a split-beam setup, the light through the filter is used as the reference beam.

Spatial filters are expensive, costing around $600.00. Images Company plans to have an inexpensive filter available around the time this book is published; the target price for their spatial filter is $200.00.

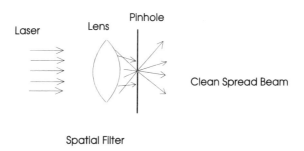

Figure B.1. Spatial filter.

Steadiness check

CHECKING AN ISOLATION TABLE
FOR VIBRATIONS

There is a very simple way to check for vibrations on a table. This technique was recommended, at different times, by both Graham Saxby and T.J. Jeong, well-respected holographers.

Materials needed:

One laser

One small white bowl

One FS transfer mirror glued to a magnet

One radius mirror glued to a magnet

One rectangle magnet ($1 \times 1 \times .5$ inch)

One jumbo magnet ($1 \times 1 \times 2$ inches)

One steel plate ($1 \times 5 \times 1/16$ inch)

One steel plate ($1 \times 10 \times 1/16$ inch)

To check the table, find a small white bowl. Fill the bowl half-full with water. Place the bowl in the center of the table; see Figure C.1. Place the jumbo magnet and long steel plate 1 inch away from the bowl. Position the radius mirror near the top of the steel plate. Using one small transfer mirror, reflect the beam from the laser up to the radius mirror. Direct the reflected beam from the radius mirror to the water-filled bowl. The laser light should reflect from the bowl onto the wall.

You will probably need to wait a few minutes for the water to completely settle.* Any vibration on the table will show up as a movement in

* If the water never settles down, there is too much vibration in this area to shoot holograms. Either find the cause of the vibration and stop it, or find another location.

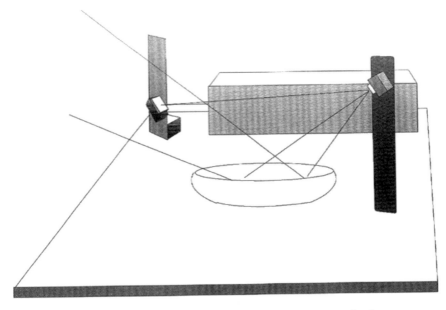

Figure C.1. Illustration of table setup for steadiness check.

the reflected light from the bowl. Once the water has settled completely, you can perform a few tests.

First, clap your hands together sharply above the water bowl. The reflected light should quiver slightly and die down. Next, stamp your feet on the floor and look for the effect on the table. Try bouncing or shifting your weight from one side to the other and gauge this effect on the table. As you perform these tests, you will get a feel for the amount of movement you can safely get away with. Finally, tap the table gently with your finger and time how long it takes for the vibrations to die down. This should become your minimum settling time after placing components on the table. This does not include lifting the shutter card off the table, which has less physical impact.

This test is also good for checking components and technique. For instance, try putting a shutter card on the table and lifting it off and look for any vibrations introduced onto the table. If you build or purchase an automatic shutter, you may want to place it on the table and activate it a few times to see if it creates any vibration that may prevent a hologram from forming, before using it in a setup.

Developer and bleach

It isn't difficult to mix your own development chemistry; however, you do need to follow some basic rules.

1. Use only distilled water to make the developer and bleach solutions.
2. Use only plastic or glass containers and utensils. *Do not use metal.*
3. The chemicals are toxic. Wear rubber gloves, goggles, and an apron when mixing chemicals. Do not breathe in any chemical dust.
4. Clean all spills immediately. Rinse utensils and containers when finished.
5. Label all solutions immediately. Write date solutions were mixed on label.

 You need two plastic containers to store your solutions. Photographic supply stores sell plastic bottles for this purpose. Purchase 1-liter capacity bottles or larger.

BLEACH SOLUTION

You need two chemicals for the bleach.

* Potassium dichromate
* Sulfuric acid (90% or greater)

 The bleach solution has a long shelf life. Measurements are given in weight, volume, and teaspoon.
 To 1 liter (4.5 cups) distilled water, add 1 milliliter (approx. 1/2 tsp.) of concentrated sulfuric acid. Add acid to water over sink in case of spills. Remember: only use plastic utensils.
 Next add 4 grams (approx. 1/2 tsp.) of potassium dichromate to the distilled water. Mix gently. Cap and label the bottle "bleach."

DEVELOPER

Kodak's Black and White D-19 is a good general developer for both reflection and transmission holograms. You can purchase pre-mixed packets of D-19 developer (just add water) from photographic supply stores. Follow the directions on the package for mixing the solution. Cap and label the bottle "developer." The D-19 developer is reusable.

Index